ART TREASURES OF
KELVINGROVE

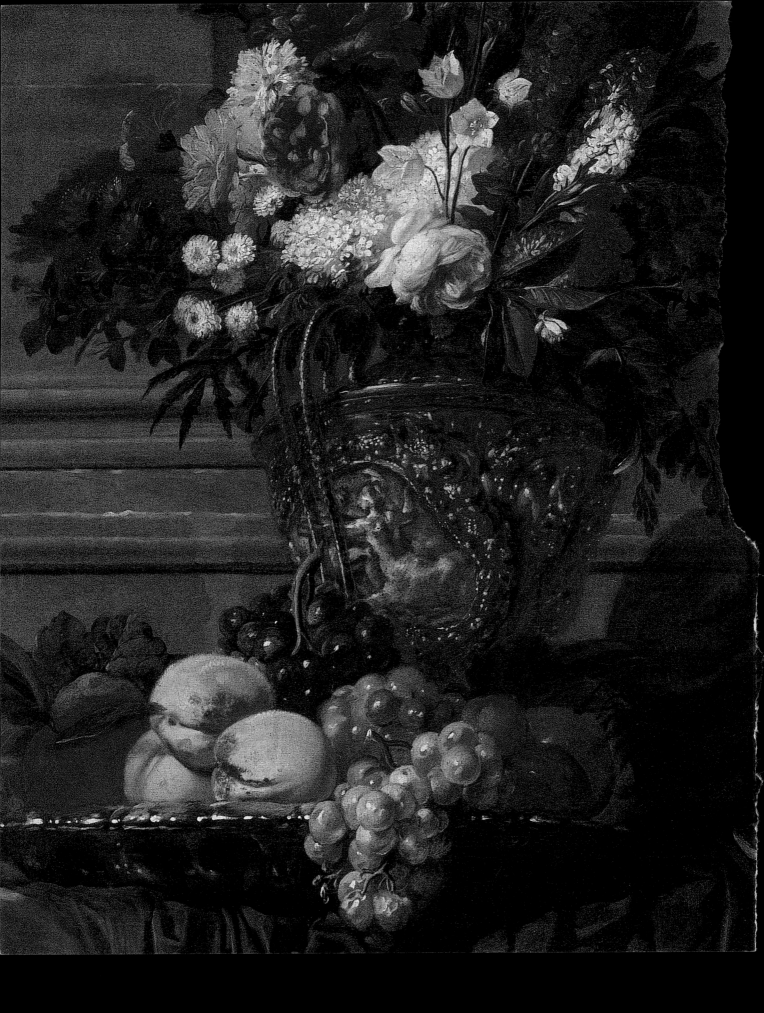

ART TREASURES OF KELVINGROVE

HIGHLIGHTS FROM GLASGOW'S
KELVINGROVE ART GALLERY AND MUSEUM

SCALA

Glasgow City Council (Museums)
in association with Scala Publishers Ltd

Text and photography © 2003 Glasgow City
Council (Museums)
The publishers gratefully acknowledge
the following for permission to reproduce
illustrations: T & R Annan & Sons Ltd
(pp 8, 14), Mrs PM Black for *Two Children*
by Joan Eardley (pp 36–7) and the Portland
Gallery, London, for *Interior – The Orange
Blind* by FCB Cadell (pp 34–5) © The
Cadell estate. All efforts have been made to
trace copyright holders, but if any have been
inadvertently omitted, please notify the
publisher.

First published in 2003 by
Scala Publishers Ltd in association with
Glasgow City Council (Museums)
Northburgh House
10 Northburgh Street
London EC1V 0AT
United Kingdom

ISBN 1 85759 3189

Project editor: Miranda Harrison,
Scala Publishers Ltd
Editors: Kirsty Devine, Vivien Hamilton
and Bill Jenkins, Glasgow Museums
Designer: Yvonne Dedman
Produced by Scala Publishers Ltd
Printed and bound in Italy

Photographs are from Glasgow City Council
(Museums) Photo Library and Photography
Department
www.glasgowmuseums.com

Half-title:
Painted gesso detail of a rose from a panel
by Margaret Macdonald Mackintosh, 1903
(see page 82)

Frontispiece:
Detail from *The Five Senses* by Gerard de
Lairesse, 1668 (see page 62)

CONTENTS

PREFACE

Kelvingrove is the best kept secret among British museums – though greatly loved in a city where museum visiting is part of everyday life, it is not nearly as well known nationally and internationally as it deserves. The current refurbishment and redisplay will remedy this and while this work is being done the *Art Treasures of Kelvingrove* exhibition at the McLellan Galleries will show a selection of the 200 greatest works in the collection.

Kelvingrove is in many respects superlative or unique. It is the last and greatest example of the Victorian municipal museum movement. Kelvingrove also reflects a triumph of the Victorian ideal of the universal museum. Glasgow's approach to creating an encyclopaedia of objects – a grand building combining the subject areas of the National Gallery, the Victoria and Albert Museum, the Natural History Museum and the British Museum – reflects the self-confidence and ambition of a city that did not doubt its role as a major player in a global market. Competition with its rival cities in the UK, Europe and America took place on the cultural as well as the economic front – especially through the great international exhibitions in 1888, 1901, 1911 and 1938. The profits from the first of these contributed a major part of the funding for Kelvingrove.

Kelvingrove also expressed the Victorian belief in self-improvement through the arts and education. At the opening in October 1902, Lord Provost Chisholm said:

The Corporation at least were satisfied that art was in itself a refining and improving and enobling thing, otherwise they would not have felt justified in doing what they have done in order to provide for the reception of so many of the citizens to view the treasures that would henceforward be housed in the building. And there was the question of the educational value of the museum and the opportunities afforded the young people and the lads and girls who had possibly outgrown the ordinary day school, and so broadening and enlarging their general culture.

Within a decade of the opening of Kelvingrove, Glasgow's economy went into a decline that only began to be reversed in the 1980s (with the opening of another museum – The Burrell Collection). Key assets in this regeneration were, and are, the Victorian architecture and the great collections bequeathed to the city by a series of major benefactors. These range from collectors of international reputation like Archibald McLellan and R L Scott (whose arms and armour collection is one of the greatest in the world), to many thousands of merchants, soldiers, missionaries, local historians and naturalists and citizens who gave prized objects to their museum. This sense of public ownership of the city's museums is palpable among the visitors – even at the height of the tourist season, the atmosphere in Glasgow's museums is that of places which are deeply embedded in the local culture, not clinical services on an international circuit.

Building on its great cultural legacy from the Victorian period, and a city leadership which saw cultural provision for all as a key factor in education and regeneration, Glasgow won the title of European City of Culture in 1990.

This brought to the world's attention something of the richness Glasgow has to offer to people looking for an exciting place for a city break, a business or academic conference, or as a European base for their business.

The introductory gallery in *Treasures* gives only a glimpse of the collections in which Glasgow is so rich. The strength in depth of the city's art reserve is reflected in the fact that this exhibition does not show works from one of the most important areas of the collection. While Kelvingrove is closed and the *Art Treasures* are on display, 64 French Impressionist and Post-Impressionist paintings are touring eight cities in the United States, Canada, Spain and Ireland. This tour includes Vincent van Gogh's portrait of Alexander Reid, a Glasgow art dealer, who was a friend of the artist, and who introduced many of Glasgow's collectors to the avant-garde art of the time. The income from this tour will make a significant contribution to the costs of refurbishment as well as promoting Glasgow overseas.

Kelvingrove is the most visited museum in the UK outside London, and the most visited free visitor attraction in Scotland. It was however greatly in need of renewal – apart from the need to renew basic services like heating, plumbing and electricity (the building has not been fully rewired since 1898!), the displays in Kelvingrove need to be brought up to the world-class standards merited by the collections.

The aim of the redisplay is to create a twenty-first-century museum within a Victorian building. The architecture will be freed of the accretions that have been added over the years and the displays will provide a wide range of experiences and atmosphere. Some will be very traditional and will appeal to the experienced museum visitor, who often wants a quiet reflective space. Other galleries will have a high level of hands-on exhibits for the 'lads and lasses' whom the museum was designed to serve from the outset. Many objects not shown for many years, or in some cases that have never been, will be on display – along with visitors' favourite objects. The 200,000 objects currently stored underneath Kelvingrove will be moved to a state-of-the-art new building – the Glasgow Museums Resource Centre, Nitshill, which will give unprecedented access to the public to see these objects. An extensive consultation process has been carried out to make sure that we did not 'improve it worse', combining the best of the new with the best of tradition.

We hope that the *Art Treasures of Kelvingrove* will give local people some comfort while their beloved museum is closed and will give visitors a glimpse of the potential of Kelvingrove, and that everyone will visit again when it reopens in 2006, taking its place among the great museums of the world.

Mark O'Neill
Head of Museums

Above:
Red amethyst and silver detail from a screen by George Logan, 1901 (see page 80)

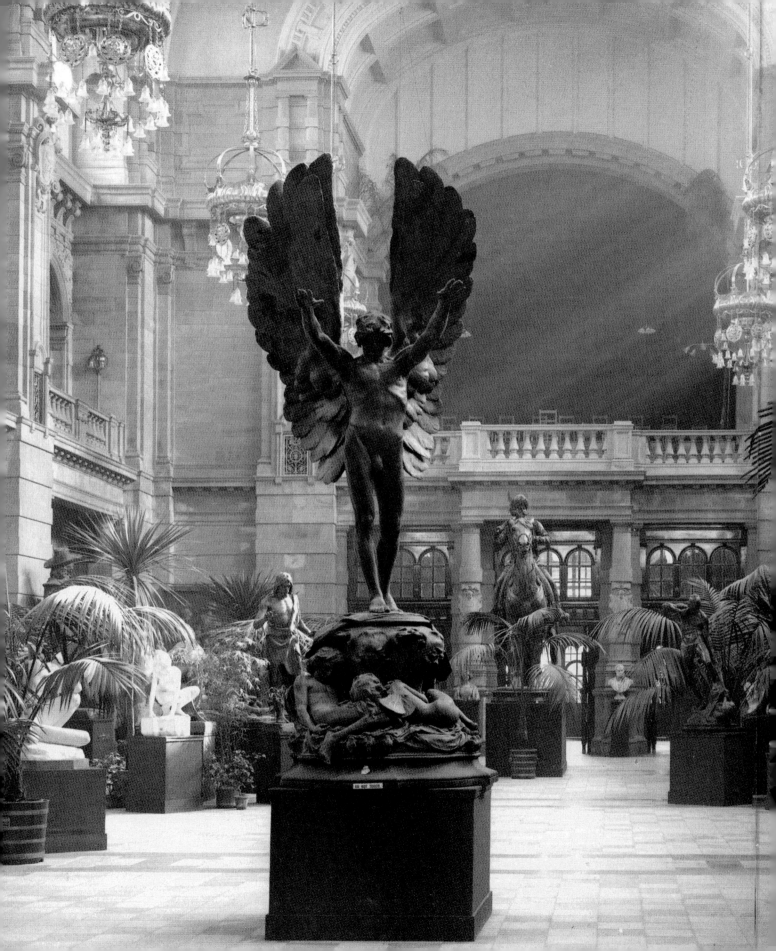

INTRODUCTION

The fine and decorative arts collections of the Art Gallery and Museum, Kelvingrove, are a source of pride for Glasgow's citizens and are justly famed worldwide. The Old Masters were given or bequeathed in the main by important local collectors, and the principal masterpieces were nearly all acquired before the present building was opened in 1901. The French collection, which is of wider appeal, is more of a twentieth century phenomenon, its period of greatest expansion being in the years 1939–54, when the most significant Impressionist and Modern paintings were acquired.

The collection of British, especially Scottish painting, has been built up by gift and by purchase over a long period, the first significant painting bought being Whistler's renowned portrait, *Arrangement in Grey and Black, No. 2: Thomas Carlyle* in 1891; it was the first by this great international artist to enter any public collection. Not surprisingly, Kelvingrove has the best collection of paintings by the Glasgow Boys, the group of painters inspired by Whistler and contemporary French Realist art, who achieved international acclaim between 1880 and 1900. Scotland's debt to early twentieth-century French painting is epitomized by the Scottish Colourists (Peploe, Cadell, Hunter and Fergusson). They were supported by Glasgow patrons and their work became a major attraction at Kelvingrove.

The building was conceived as both an art gallery and a museum, a combination that appeals to a wide audience. With visitor figures averaging one million per year, Kelvingrove is one of the top cultural venues in the UK.

Central Hall, Kelvingrove Museum and Art Gallery during the Glasgow International Exhibition, 1901. Photograph by J Craig Annan.

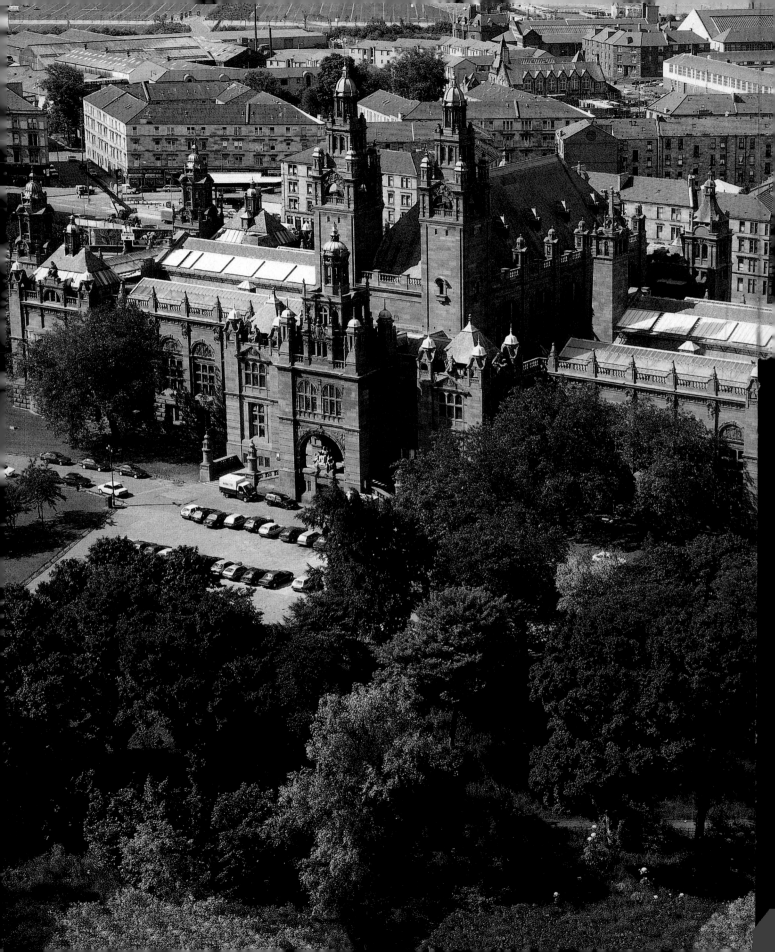

History of Kelvingrove

The Origins of the Collections, 1854–88

The new Art Gallery and Museum first opened its doors to the public on 2 May 1901, when it formed a major part of the Glasgow International Exhibition. But to understand how it came to be built one has to go back to 1854, the year of the death of Archibald McLellan (born 1797), coach builder, prominent Glasgow citizen and art collector. McLellan bequeathed his collection of over 400 paintings, along with the building for their display that still bears his name, to the people of Glasgow.

McLellan's paintings still form the backbone of Glasgow's Old Master collection. The Dutch and Venetian schools are well represented, one of the key paintings being *The Adulteress brought before Christ*, by Giorgione and/or Titian. Early views of the interiors of the McLellan Galleries show the paintings hung in typically Victorian fashion, with pictures ranged one above the other. At first the collection does not seem to have been greatly appreciated by the people of Glasgow. The rooms were used more for receptions and dances. When the Glasgow Institute of the Fine Arts was founded in 1861, its annual exhibitions were held here, the collection being taken down to accommodate them.

More paintings were added by gift and bequest in the years that followed, including in 1877 the collection of the portrait painter John Graham-Gilbert (1794–1866). The star painting of this collection is Rembrandt's *Man in Armour*.

In 1870 the City Industrial Museum was opened in the former Kelvingrove Mansion, a fine building of 1783 in the Adam style which had been absorbed into the new Kelvingrove Park.

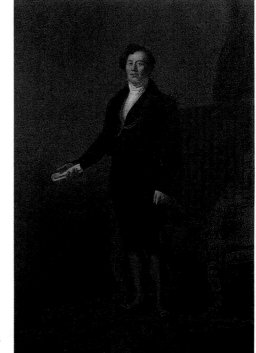

Left:
The Art Gallery and Museum from the University Tower, *c.*1990.

Right:
Archibald McLellan, 1906, Robert Cree Crawford (1842–1924), oil on canvas, after the painting by John Graham (1839), 247.6 × 165.1 cm, purchased 1906.

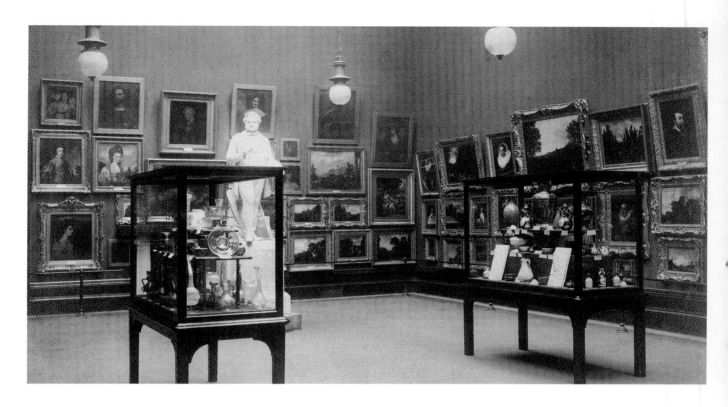

James Paton was appointed the first overall Superintendent in 1876, in charge of the McLellan (or Corporation) Galleries of Art and of the Kelvingrove Museum, as they became known. Paton made a huge contribution to the arts in Glasgow. Under him the Galleries were improved and a series of special exhibitions was held. Thereafter, as the museums' annual report observed, Glaswegians 'discovered that they possess an Art Gallery, which, in several respects, is entitled to rank with famous galleries, and an institution which they may not only enjoy themselves, but point out with pride to strangers as one of the sights of the city'.

In 1886 Paton and James Hunter Dickson, Chairman of the Museum and Galleries Committee, reported that both buildings were overcrowded, and the McLellan Galleries were a serious fire hazard, which endangered the collection and hindered their proper use. 'The urgent want of the Art Galleries and Museum of Glasgow is an instalment of a permanent building erected on a convenient and accessible site, sufficiently isolated to secure it from the risk of fire'. Their preferred site was in Kelvingrove Park.

The East Room of the first floor of the McLellan Galleries in 1902.

A New Home for the Collections at Kelvingrove

The International Exhibition of 1888 was held in Kelvingrove Park, backed by Glasgow's business and professional elite. Besides being a statement of national and local pride and a rival to recent exhibitions in Edinburgh and Manchester, it was also the essential means of funding the much-needed new Art Gallery, Museum and School of Art. The main temporary building of the Exhibition stood virtually on the site now occupied by the Art Gallery and Museum, facing the River Kelvin and the University.

Visited by 5.75 million people, the Exhibition yielded a profit of over £40,000. The Association for the Encouragement of Art and Music in the City of Glasgow then increased this figure by public subscription to over £120,000 and launched

an open architectural competition for the new building in 1891. Paton was largely responsible for the brief, which required: a central or music hall giving easy access to all parts of the building; a suite of top-lit art galleries; museum halls, some roof-lighted, some side-lighted saloons; and a school of art with separate entrance (this was later dropped from the scheme). The construction was to be fireproof throughout.

In 1892 the adjudicator, Alfred Waterhouse RA declared the winners to be John W Simpson and EJ Milner Allen, joint architects, of London. They described their design as 'an astylar composition on severely Classic lines, but with free Renaissance treatment in detail'. Although it combines a variety of styles, the best description is Spanish Baroque; indeed, the two main towers are inspired by those of the great pilgrimage church of Santiago de Compostela.

In 1896 the building was transferred to the Town Council for completion, as the Association had exhausted its funds, and the foundation stone was laid on 10 September by the Duke of York (later King George V). The final cost was to be in excess of £250,000. Looking ahead, the Council made the bold decision to hold a second International Exhibition on the site, this time to celebrate the opening of the new Galleries, planned for 1901.

A scheme for sculpture was devised by the senior architect, Simpson, and the renowned sculptor, George Frampton RA. Frampton created the prestigious bronze group at the main (north) entrance, depicting *Saint Mungo as Patron of the Arts*, together with the low sandstone reliefs around the porch. The entrance is topped by four huge carved figures by Derwent Wood RA depicting Music, Architecture, Sculpture and Painting, while other figures by lesser sculptors and low reliefs decorating the exterior and interior are redolent of arts and learning, local and national pride.

Ask any Glaswegian about Kelvingrove, and he or she will probably repeat the urban myth that the museum was built the wrong way around, and that the architect leapt to his death from one of the towers! The fact that the main entrance is from the park, while most visitors enter from the main road, Argyle Street, on the more sunny south side, may account for this enduring nonsense.

Perspective Drawing of the Principal Buildings of the Glasgow International Exhibition, 1888, James Sellars (1843–88), pen and wash, purchased 1893.

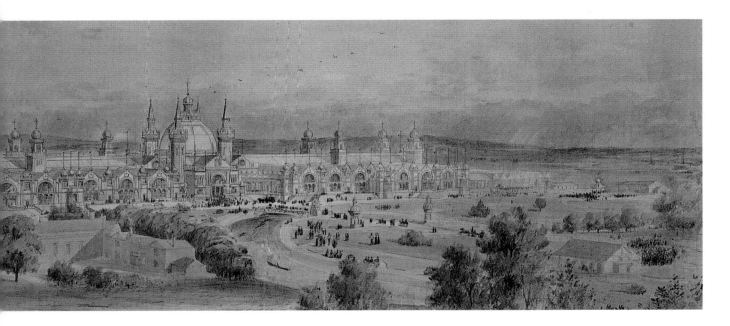

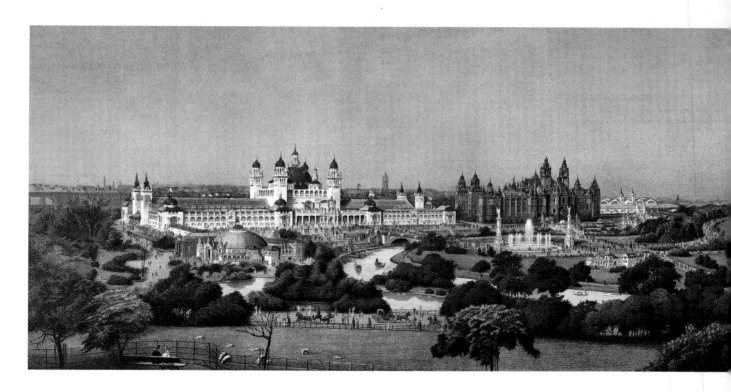

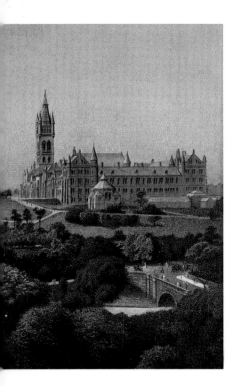

Above:
Panaramic view of the Glasgow international Exhibition, produced by Maclure & Macdonald, printers, 1901.

Left:
Kelvingrove Museum and Art Gallery opening day, 1901.
Photograph by J Craig Annan.

Kelvingrove never looked more splendid than it did on opening day, 2 May 1901. The temporary buildings of the International Exhibition presented a feast of white, gold, red and green. The main Industrial Hall, in a florid Spanish Renaissance style, was a perfect foil to the adjacent sturdy new red sandstone building by Simpson and Allen.

Princess Louise, Duchess of Fife, eldest daughter of the new King Edward VII, opened both the Exhibition and the Art Gallery and Museum. The new building hosted a huge loan display of mainly British art. The most eye-catching section was the Central Hall, which fulfilled its intended long-term purpose as Sculpture Court. Potted plants and palm trees complemented the marbles, plasters and bronzes by contemporary British and European sculptors, including Rodin. Many have yearned for the return of that display!

The International Exhibition attracted 11.5 million visitors. The profit of £39,000 was set aside for the promotion of art and science in the city, becoming effectively the museum's purchase fund for half a century.

The Early Years at Kelvingrove
After closure the site was cleared of the temporary buildings and returned to parkland. Then began the huge task of installing the displays from the old Kelvingrove Museum (demolished 1899) and the Corporation (McLellan) Galleries in the new Art Gallery and Museum in time for opening on 25 October 1902. Simpson created a splendid polished walnut case-front and display pipes for the magnificent Lewis & Co (London) organ, which was bought after the Exhibition to be the feature of the Central Hall.

The layout was simple, a result of Paton's planning: Fine Arts on the upper floors; Natural History in the East Wing; Technology and Archaeology in the West Wing; and Sculpture in the Central Hall; an arrangement which survived largely intact for the next hundred years.

The new building was an enormous success, with annual attendance of 1.1 million visitors in 1903, repeated in 1904. Glasgow's ratepayers voted for Sunday opening in 1905. An annual drawing competition for children was established in 1904. This competition has been very successful in introducing young people to the collections and this has ensured its continuation to the present day.

The purchase fund was used to enrich the art collections, but the buying committee was conservative by today's standards. Bequests such as that in 1905 of James Donald, a local chemical manufacturer, were of more significance; it included French Barbizon and Realist pictures, which formed the foundation of the Gallery's Impressionist collection. In 1913 an inspired purchase was made of Bastien-Lepage's *Poor Fauvette*. Like the Whistler portrait of Carlyle, this painting is of added significance for our collection because of his influence on the Glasgow Boys.

The Great War had an effect on the institution, most tragically in July 1915 when Gilbert A Ramsay, the newly appointed Superintendent of Museums, was killed in action at the Dardanelles. The annual report of 1917 noted the presence of many wounded and colonial soldiers among the visitors. Newspaper articles suggested that the Museum might become a military hospital, but nothing came of this.

The 1914 figure of around 1,000 oil paintings in the collection rose by the outbreak of war in 1939 to over 1,500. During this period, two British institutions still active today, the National Art Collections Fund and the Contemporary Art Society, began to help the Gallery with the acquisition of works of art.

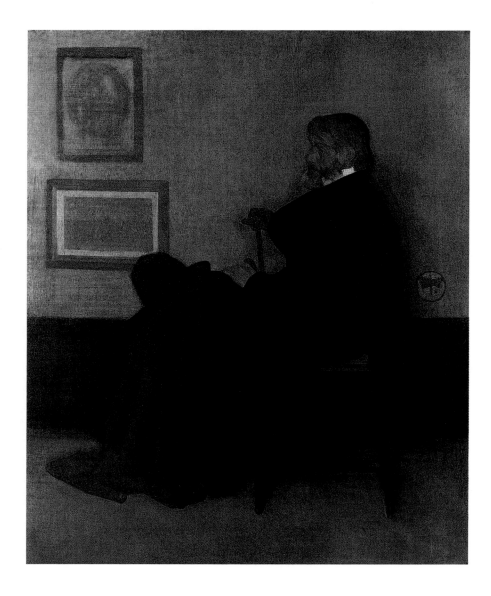

The major art acquisition of the period was the gift in 1925 by the shipping magnate William Burrell of 48 paintings and drawings, including 23 by important French artists of the Realist and Modern schools, a precursor of the later Burrell gift in 1944. Another significant benefaction was the Hamilton Bequest, which came into effect in 1927. This combined the estates of the late John Hamilton, storekeeper, and his two sisters Elizabeth and Christina, to give a sum of money solely intended for the purchase of oil paintings for Kelvingrove. This fund is still administered by the Hamilton Trustees today and has presented some 80 paintings to the gallery, many of outstanding quality.

The Honeyman Era, 1939–54

The appointment in 1939 of Dr Tom J Honeyman (1891–1971) as Director marked the beginning of an exciting new era at Kelvingrove. Honeyman was already well known in Glasgow artistic circles as a dealer. Under him a series of successful exhibitions took place, publicity and public activities gave the building a higher profile, and the collection of French paintings assumed international importance.

Wartime emergencies led to the evacuation of the Old Master paintings, and the annual exhibitions of the Royal Glasgow Institute of the Fine Arts were held here between 1939 and 1946 instead of at their normal venue, the McLellan Galleries.

Plaster casts in the Sculpture Court were a major casualty of the Blitz when a landmine dropped nearby in Kelvin Way in 1941, shattering 50 tons of window glass; the Central Hall became henceforth a venue for special temporary exhibitions. In 1941 the Schools Museum Service (now the Museum Education Service) was founded, one of the first of its kind in Britain. Funded by the Corporation Education Department, it led to a huge increase in use of the collections and in the quality and quantity of visits by young people. The Glasgow Art Gallery and Museums Association (now the Friends of Glasgow Museums) was formed in 1944 and generated a lively interest in events, lectures and activities. The renowned collector William McInnes (1868–1944), a Glasgow ship owner, bequeathed his art collection to the city – paintings, drawings, prints, silver, ceramics and glass. Thirty-three of our most important French paintings were included in this bequest, and McInnes also championed the work of the Glasgow Boys and the Scottish Colourists.

The great art event of wartime was the gift in 1944 by Sir William and Lady Burrell of their fabulous collection, followed by a sum of money to provide a gallery for its display. Housing it was to be a major preoccupation of the city for nearly 40 years, during which time many wonderful works of art enriched the displays at Kelvingrove.

Dr TJ Honeyman.

When war ended, the most valuable works, which had been housed secretly in various parts of the country, could be returned for display, but it took until December 1947 for the west galleries to be redecorated and hung according to the familiar classifications by school: Italian, Flemish, Dutch and French. Two very special exhibitions took place in the years after the war, which are recalled to this day not only for the quality of their art, but also for the queues of visitors snaking round the outside of the Gallery: *Picasso–Matisse* in 1946 and *Van Gogh* in 1948.

The most publicized event of 1952 was undoubtedly the purchase of Salvador Dali's iconic *Christ of St John of the Cross*, painted in 1951. The Corporation Committee was so enthusiastic when purchase was proposed that they decided to use what remained of the 1901 Exhibition Surplus Fund to meet the price of £8,200. This they did despite protests on aesthetic and financial grounds, and the public generally accepted the picture with pride and wonderment. It has continued to draw visitors to Glasgow ever since, although it still attracts a measure of controversy. In 1993 it was moved to the pioneering new St Mungo Museum of Religious Life and Art beside Glasgow Cathedral. Honeyman is remembered as 'The man who bought the Dali' and for putting Kelvingrove back on the map. He received several high honours both before and after his retirement in 1954.

Stability and Renewal:
Kelvingrove since 1954

Throughout the 1950s and 1960s there was more emphasis on the museum side of activity at Kelvingrove, with frequent exhibitions devoted to industrial themes. There was also a continuing programme of modernization of displays after the wartime dispersals.

The presence of star items from The Burrell Collection, either as part of special exhibitions or else integrated with the general collections, acted like a magnet for art lovers. The combined displays of French paintings at this time were particularly strong and remained at Kelvingrove until the Burrell opened in 1983.

In 1974 Van Gogh's portrait of *Alexander Reid*, which has since become a symbol of the Kelvingrove collection, was bought from the sitter's grandson for £166,250, the highest yet paid by the Gallery. The cost was secured with the assistance of a Government grant and contributions from an anonymous London trust, the National Art Collections Fund and a fund-raising committee of Glasgow Art Gallery and Museums Association. Many today still take pride in their part in buying this masterpiece.

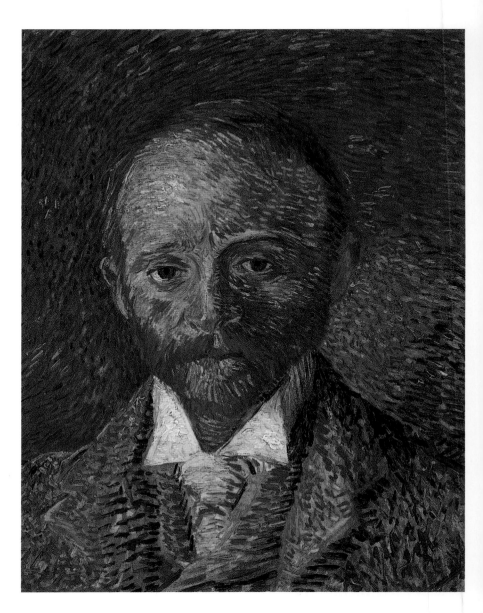

Alexander Reid, 1887, Vincent van Gogh (1853–90), oil on canvas, 42 × 33 cm, purchased 1974.

The neglect of Glasgow's greatest artistic genius Charles Rennie Mackintosh began to be rectified in the 1970s by the display of some items rescued from his demolished Glasgow tearooms. The acquisition of Mackintosh and related material gathered pace. In 1978 a loan exhibition of his stunning watercolours was assembled and went on to tour the UK. All this, together with other initiatives such as those of the University's Hunterian Art Gallery, the School of Art and the Charles Rennie Mackintosh Society, were steps on the road to proper recognition of this artist, designer and architect.

External stone cleaning was undertaken through 1987, and the ailing organ completely overhauled for the first time since 1951. These projects were completed in time for the celebration in Glasgow in 1988 of the UK Garden Festival.

A new, radical redisplay of the picture galleries at Kelvingrove was made in time for Glasgow's reign as European City of Culture in 1990. After 1990 the tempo remained high, with exhibition budgets and sponsorship well in excess of what they had been in the preceding period.

Despite a massive cutback in the acquisition fund, some major purchases have been made recently through the assistance of government grants, the National Art Collections Fund, the Hamilton Bequest and the Heritage Lottery Fund, a recent and very significant player on the scene.

The series of cultural accolades awarded to the city continued in 1999 under the title of UK City of Architecture and Design. Again Kelvingrove was one of several venues for major exhibitions, including the international touring show *Frank Lloyd Wright and the Living City*.

In the run-up to the centenary of the building in 2001, the City Council began to prepare for a complete refurbishment and radical redisplay at Kelvingrove under the title of *New Century Project*. After much research and wide public consultation, a plan was put in place for a £25.5 million scheme. The award of a grant of £12.8 million from the Heritage Lottery Fund, announced on 31 January 2002, allowed the project to go ahead. Funding of the remainder is to be secured from other partners, including the City Council, Kelvingrove Refurbishment Appeal Trust (chaired by Lord Norman Macfarlane), the European Regional Development Fund and Historic Scotland. An increase in display space will be created by the removal of offices, workshops and storage off site, and the opening up of the basement area. The integration of art and museum displays, and the commitment to attracting new audiences is expected to increase visits, previously averaging one million per year, by as much as a third. The importance of the art collections will remain a magnet for visitors from home and abroad, enhanced by improved display and interpretation.

The Glasgow Style Gallery, 1984.

BRITISH PAINTING
JEAN WALSH

Mr and Mrs Robert N Campbell
of Kailzie, c.1795
Sir Henry Raeburn (1756–1823)
Oil on canvas
241.3 × 152.4 cm
Bequeathed by Isabella A H J Campbell, 1917

The most accomplished Scottish portrait painter of his day, Raeburn's success was due in part to the emergence of the city of Edinburgh towards the end of the eighteenth century as a centre of intellectual and commercial excellence.

Portraying the most important society figures of the time, including writers, philosophers, religious leaders and wealthy landowners, Raeburn's pictures can be regarded as the artistic embodiment of the Scottish Enlightenment. His outstanding gift was his ability to convey the personality of his subject in a few apparently effortless brushstrokes. His English rival, Sir Thomas Lawrence, remarked that: 'Mr Raeburn's style is freedom itself.'

This striking double portrait, probably dating from the early part of Raeburn's career, uses a subtle fusion of arresting composition and dramatic light and shade to create a sense of intimacy between the spectator and the people portrayed.

Possibly painted to commemorate the acquisition of their estate at Kailzie in Traquhair, Peebleshire in 1794, the contented couple is depicted strolling arm-in-arm in the grounds. The stillness, the boldly sketched landscape setting and the sense of the fleeting moment combine to create a hushed atmosphere that is simultaneously formal and verging on the romantic. Raeburn employs a favourite compositional motif whereby the principal forms are placed against a strong light source so that their facial features are well lit and the viewer is therefore compelled to engage with the intensity of their gaze.

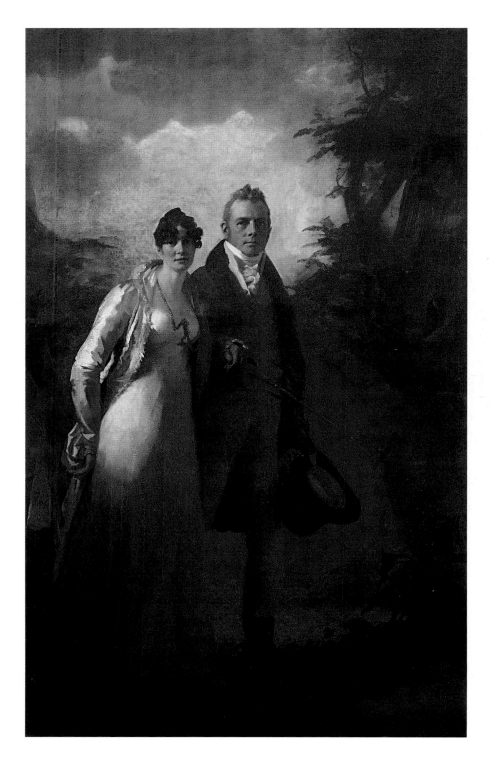

Modern Italy – The Pifferari, *c.*1838
Joseph MW Turner (1775–1851)
Oil on canvas
92.6 × 123.2 cm
Presented by the sons of James Reid of Auchterarder, 1896

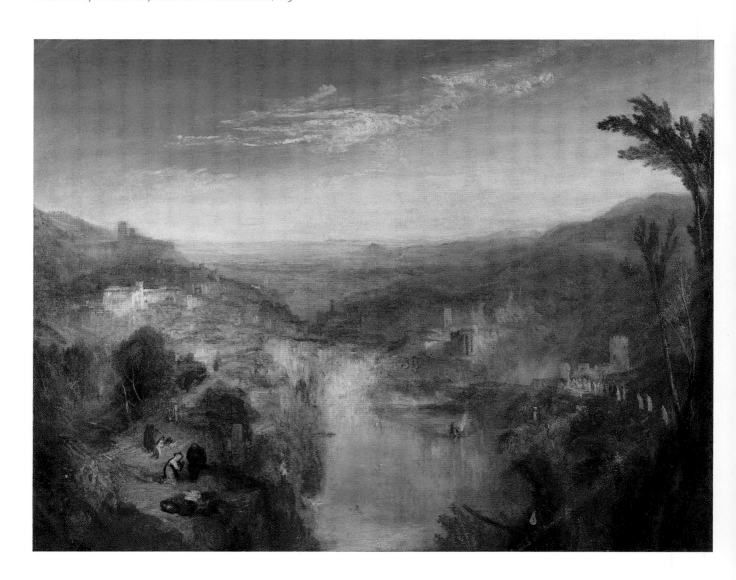

Turner travelled extensively in this country and abroad to find engaging motifs for his landscapes and was particularly inspired by Italy, its classical past and its Roman Catholic ceremonies. His approach to landscape painting was essentially a romantic, idealized one and his work was often criticized as having an unfinished quality. Constable, his artistic rival, described it as 'airy visions, painted with tinted steam'.

Although the subject of *Modern Italy – The Pifferari* may appear to be light – the brilliance of which dissolves the view of

Tivoli and the Roman Campagna – Turner was inspired by the great seventeenth-century landscape painter, Claude Lorrain. Appealing to contemporary taste, Turner records 'picturesque' Catholic practices such as the woman confessing to a monk (left foreground) and a procession with banners and crucifix, wending its way towards a church (lower right). However, the most intriguing element in the scene is the group (lower left), the *pifferari* or strolling musicians who, armed with bagpipes and *pifferi* (a sort of oboe), came to Rome each Christmas from southern Italy to play at wayside shrines and street-corner

images of the Madonna in the belief that their music relieved her labour pains. Virtually all contemporary travel writers who visited Rome at Christmas remarked upon this unusual custom and the subject was depicted by other artists including the Scottish artist Sir David Wilkie.

Allegedly the custom had its roots in a pagan tradition connected with Ovid, who encouraged the worship of the gods with music, and it was probably this association with the Roman poet Ovid that prompted Turner to paint a companion piece, *Ancient Italy – Ovid banished from Rome*. Both paintings were shown at the Royal Academy in 1838. Together they explore the interrelation between the past and the present, set against the constant factor of the annually renewed beauty of the natural world. That the idea of birth and new life was the underlying meaning of *Modern Italy* has been confirmed by the discovery of an engraver's proof for the subject on which Turner requested that a bird's nest with eggs and a child wrapped in swaddling clothes be added in the foreground.

Both paintings were first owned by a Scotsman, HAJ Munro of Novar, a personal friend and principal patron of Turner. However, they did not stay together, our picture passing through several collections after the 1867 Munro sale until it was presented to the Gallery by the sons of its last owner, another Scot, James Reid of Auchterarder in 1896.

The Last of the Clan, 1865
Thomas Faed (1826–1900)
Oil on canvas
144.8 × 182.9 cm
Purchased 1980 with aid from the Heritage Fund for Scotland and
contributions from the National Art Collections Fund, The Pilgrim
Trust, the Glasgow Print Studio and public subscription

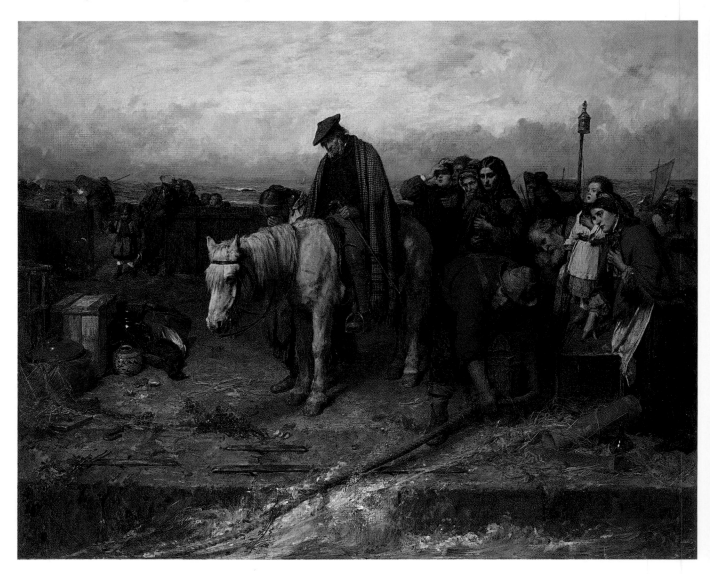

Exhibited at the Royal Academy in 1865, this painting was
accompanied in the catalogue by a paragraph probably
written by the artist himself to explain the scene:

> When the steamer had slowly backed out, and John MacAlpine
> had thrown off the hawser [rope], we began to feel that our once
> powerful clan was now represented by a feeble old man and his
> granddaughter, who, together with some outlying kith-and-kin,

myself among the number, owned not a single blade of grass in
the glen that was once all our own.

A vivid sense of actuality is given to the composition by the
unusual viewpoint. It is as if we, the viewers, are present on
the deck of the boat as it draws away from the quayside and
witness the varying emotions shown on the faces of the group
left behind – the sad resignation of the bent old man on his

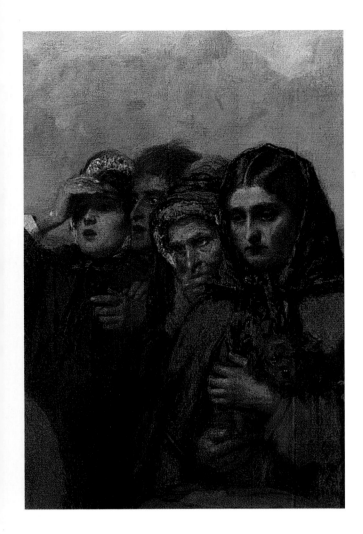

pony, the heartbreak of his grand-daughter and the worry and fear of other onlookers.

Such emigrant scenes were common occurrences in mid-nineteenth-century Scotland when, partly as a result of the Highland Clearances, the land could no longer support the people. Emigration, often forced, to places such as America and Canada, was the only hope of survival. Though sometimes, as depicted here, the very young, women and the old were not allowed to go, and only able-bodied men sailed to the colonies in the first instance.

A masterpiece of genre painting on a relatively large scale, Faed combines an eye for detail with a fluent painterly manner. The high quality of the still life painting of objects strewn on the quayside – a ginger jar, a pheasant, pots and packing cases – and the rich touches of colour, particularly in the costumes worn by the figures, are typical of Faed at his best and reveal a Pre-Raphaelite influence.

These elements are set amidst a fine landscape with a breezy sky and distant choppy sea. All in all, Faed brings an epic quality to a subject which is charged with tragic emotion and powerful immediacy.

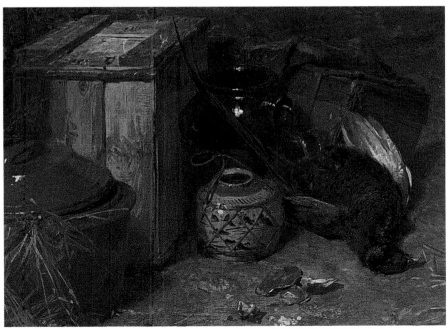

Regina Cordium: Alice Wilding, 1866
Dante Gabriel Rossetti (1828–82)

Oil on canvas

59.7 × 49.5 cm

Hamilton Bequest, 1940

The work of the artists of the Pre-Raphaelite Brotherhood is rare in Scottish collections. This is an outstanding example. Rossetti, son of a professor of Italian language at King's College, London, was one of the founders of the Brotherhood in 1849, dedicated to the revival of the excellence of the traditions of artists and craftsmen of the Middle Ages. They took their name from their interest in the Italian painters of the fifteenth century, from the period before Raphael. The Pre-Raphaelites sought to create a different type of pictorial beauty from that which was generally accepted.

Regina Cordium, translated as Queen of Hearts, is a portrait of Alice Wilding, a red-haired woman, one of several whose looks captivated Rossetti. She is seen in front of a cherry tree trained over a framework against a gold background, a pictorial device used widely in medieval art. The picture is full of symbolic meanings, most of which are to do with love or matters of the heart. A jewel at her neck shows a flaming heart superimposed on crossed arrows, surmounted by a crown. Hanging from a branch of the fruit tree is a heart-shaped medallion depicting a blindfolded Cupid, the god of love, carrying a bow and arrows. He was said to spark love in his unsuspecting victims by firing his arrows indiscriminately into their hearts. The woman holds an iris, a flower similar to the lily, which denotes purity and is usually associated with the Virgin Mary.

In front of the parapet there are pink roses, an obvious symbol of love. These were painted directly on to the white background while the paint was still wet, thus giving added intensity to the colour. The woman's red dress and her hair are painted over the gold ground to achieve a luminous effect.

The face is a typical vision of Pre-Raphaelite beauty, delicately pale skin and haunting eyes contrasting with sensuous lips. In it we see perhaps a memory of Rossetti's wife Elizabeth Siddall, his idol and model until her death after two years of marriage in 1862. HS

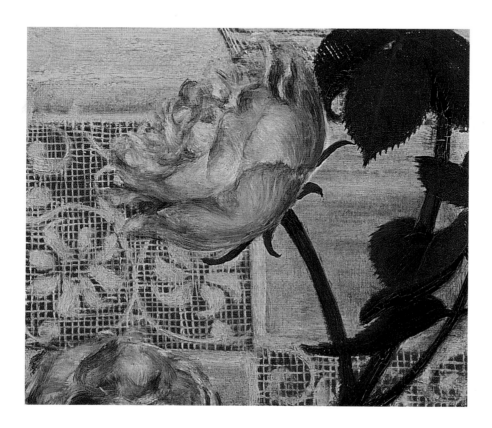

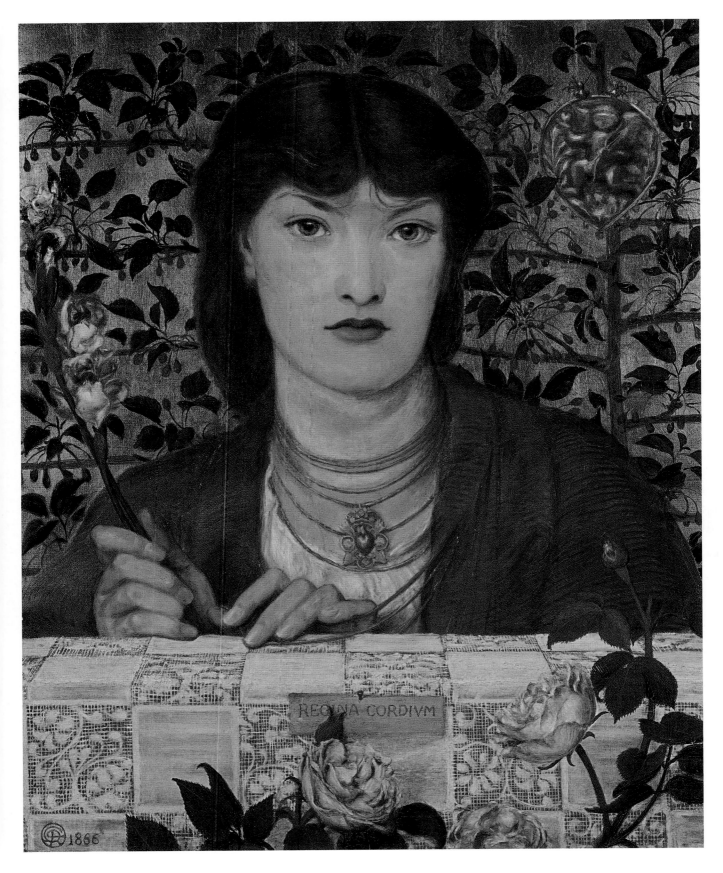

REGINA CORDIVM

The Fairy Raid: Carrying off a
Changeling – Midsummer Eve, 1867
Sir Joseph Noel Paton (1821–1901)
Oil on canvas
90.5 × 146.7 cm
Presented by A Robertson Cross, 1965

Fairy painting reached the height of its popularity during the Victorian era. Although primarily a religious painter, Paton also painted several literary and romantic compositions, the subjects of which were ideally suited to his love of dramatic incident and vivid imagination. He had studied at the Royal Academy Schools with John Everett Millais and formed a lifelong friendship with him, but left London in 1844, four years before the Pre-Raphaelite Brotherhood was formally founded. However, his art has many affinities with the group, notably his intense observation of nature, a microscopic attention to detail and rich, brilliant colours.

Belief in fairies, folklore and the world of the supernatural still held sway in the polite society of eighteenth- and nineteenth-century Scotland and came under the scrutiny of Sir Walter Scott in one or two essays, particularly *The Minstrelsy of the Scottish Border*, published in 1803. In this he confirmed that even if in reality all fairies were dead, they were still very much alive in popular superstition. The image of the fairy cavalcade as described by Scott in the *Ballad of Alice Brand* may well have been the inspiration for Paton's picture:

'Tis merry, 'tis merry in Fairyland,
When fairy birds are singing,
When the court doth ride
By their monarch's side,
With bit and bridle ringing.

Paton combines the 'fairy rade', or parade of fairies with the 'changeling' legend – another traditional belief that fairies could carry off a new-born child leaving a fairy baby as a substitute. Set at twilight in a dark wood, the pictured

scene is less innocent than it first appears. While the large fairies are the conventionally beautiful and aristocratic figures of medieval romance, their smaller attendants are the grotesque creatures more often associated with folklore. Other human children identifiable by their size (lower left) wear slender chains around their ankles; one child in particular looks back wistfully at the human world he is leaving behind. A recent interpretation of the picture has highlighted the child abduction theme and reasoned that Paton was simultaneously enthralling his audience and increasing their anxiety about this issue which was all too common in Victorian society.

Whether or not this was Paton's intention, the picture is a remarkable *tour de force*. All is rendered with a breathtaking, meticulous attention to detail, the woodland scene bursting with imaginary fairies, knights in armour, fantastic creatures and lush flora and fauna. There are even standing stones on a hill in the distance, making a link with ancient Celtic beliefs in which the artist was so interested. Paton has thus brought together antiquarianism, folklore and chivalry in a typically mid-Victorian way.

Reading Aloud, *c.*1884
Albert Moore (1841–93)
Oil on canvas
107.3 × 205.7 cm
Presented by Andrew T Reid, 1908

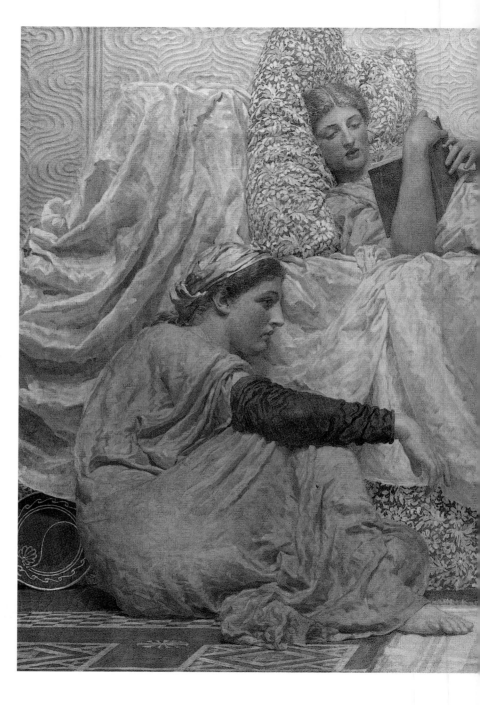

Moore is known for his timeless, almost frieze-like paintings of motionless classically draped female figures framed by decorative objects, and this work is considered to be one of his masterpieces. There is no hidden meaning, no story to tell; the figures are simply lazing around reading books. During the Victorian period there was a revival of interest in a wide variety of historical styles. Influenced by this, Moore was willing to blend different cultural sources to achieve what his biographer, AL Baldry, has described as 'art as decoration pure and simple'.

Classical art was very popular at this time and many artists were inspired by the sculptures of the Parthenon brought back from Athens by Lord Elgin and displayed in the British Museum. In Moore's painting the clinging draperies and poses of the figures can be traced to the three goddesses of the east pediment.

The decorative arts objects in the room take up the classical theme with motifs associated with Greek culture such as the owl, emblem of the goddess Athena, on the vase. The artist even adopted the Greek *anthemion* (honeysuckle) motif, seen on the black bench and on the mirror holder, as his own personal mark or signature.

Japanese art, championed by Whistler, was also in vogue, and Moore's awareness of *ukiyo-e* prints, which often depict elaborately draped figures arranged across the surface plane of the picture, is evident in this composition.

A third influence is Moore's interest in Orientalism and the art of the Middle

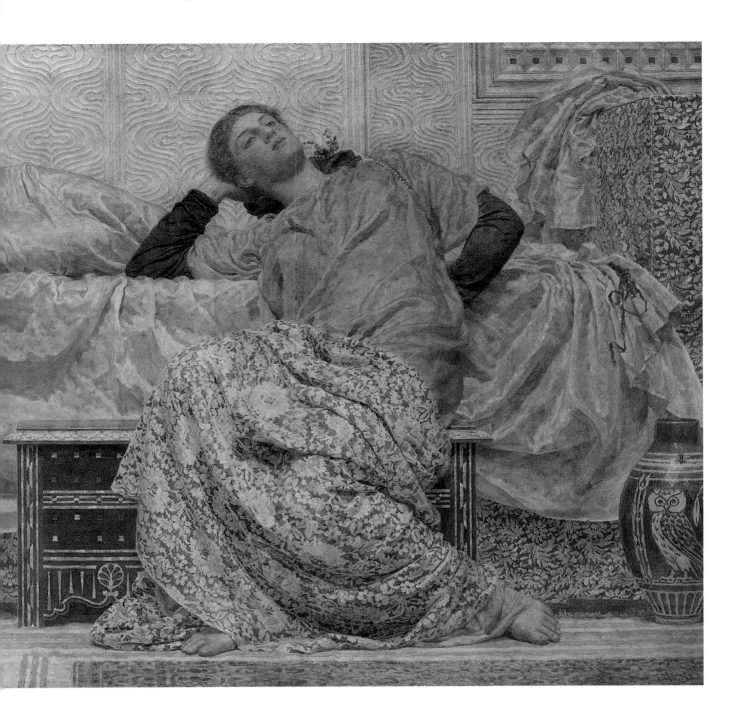

East. The decorative tile work and patterned carpets so characteristic of lavish Middle Eastern interiors are evident here and may well have been inspired by the Arab Hall built for his fellow artist Frederic Leighton, who lived near Moore in London's Holland Park.

This painting no doubt appealed to the Victorian love of fusing different artistic styles and recreating times past, but Moore's aesthetic aim was to create a decorative harmony in pink and white and grey. In order to arrive at a clean and perfect working finish, he made several preliminary sketches and cartoons on paper which were later transferred to the canvas for copying. The tiny pin holes from the pins that attached these sketches to the canvas and an irregular grid of pencil guidelines can be seen all over the picture. Moore's working method differed from that of his friend Whistler, but their shared idea was to create harmonious, balanced arrangements of restrained colour and form on the canvas.

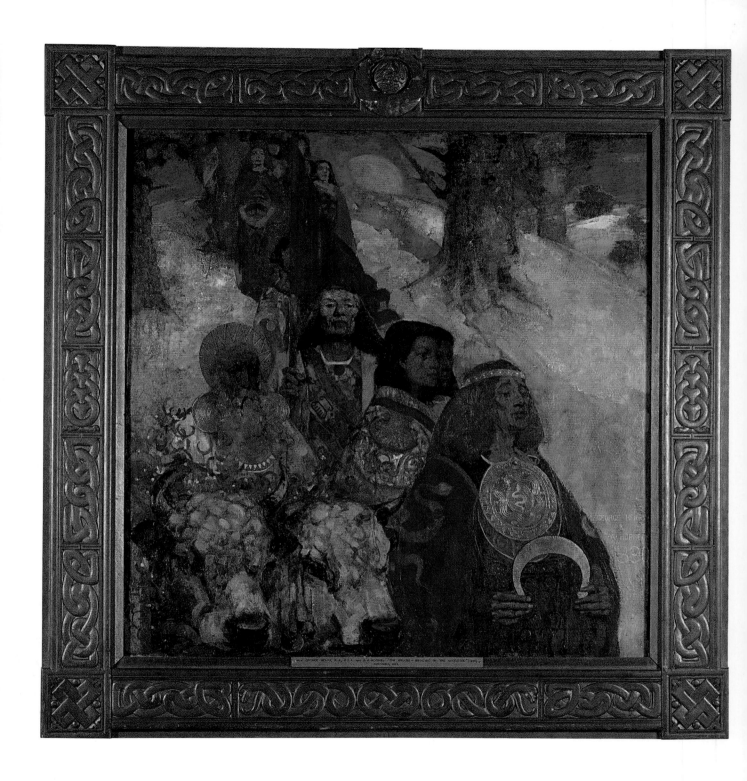

The Druids – Bringing in the Mistletoe, 1890
George Henry (1858–1943) and
EA Hornel (1864–1933)
Oil on canvas
152.4 × 152.4 cm
Purchased 1922

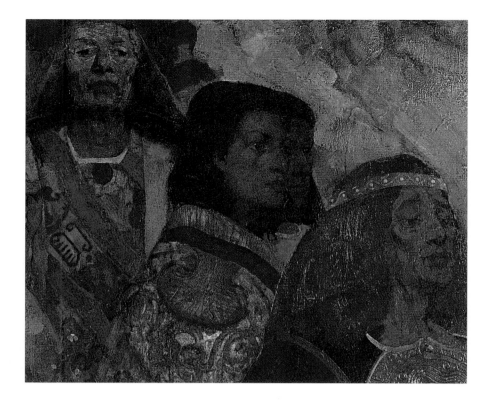

George Henry and EA Hornel were responsible for producing the second, more decorative phase of the Glasgow Boys' work from around 1885. Their paintings were characterized by strong colour and by a greater emphasis on pattern and line. They first met in 1885 when Hornel came to Glasgow and they shared a studio, but their close friendship soon developed into artistic collaboration and *The Druids* is one of the first known pictures that they painted together.

Interested in archaeology and folklore throughout his life, Hornel probably chose the subject matter. He was reputed to have visited Sinclair, an old man in the Galloway area, who provided further inspiration for the painting. Clutching a piece of mystic stone '... he [Sinclair] seemed to go off in a sort of trance, and then began to describe, like a wireless announcer of today, a vision of priests with sacred instruments and cattle which somehow were connected with the cup-and-ring markings ...'

True to the vision, the picture does indeed show a group of Celtic priests or druids in richly decorated ceremonial robes and insignia proceeding down a steep hillside from a sacred oak grove. Accompanying them are the Caledonian wild cattle, their horns bedecked with mistletoe, a plant venerated by the druids for its magical as well as medicinal properties.

Daring in conception, strong in colour and bold in execution, the picture ranks as one of the most important works ever painted by the Glasgow Boys. Henry and Hornel emphasize two-dimensional decorative qualities by using a high horizon line – the moon is only just visible at the brow of the hill and only the bases of the tree trunks are included. The flat pattern effect is further enhanced by the elimination of aerial perspective – the colours and tones in the distance are just as strong as those in the foreground. And lastly, the composition itself increases the feeling of flatness

with the main figures being brought close to the foreground but forming almost a pyramid with the group of figures at the top of the canvas.

An overall decorative unity is achieved by the balancing of shapes and patterns on the Druids' gowns and priestly insignia with the natural curves and shapes in the surrounding landscape. This extends to the painting's frame, also designed by the two artists and bearing Celtic shapes and motifs. The rich reds, greens and blues and the use of gold leaf in the painting itself (which was at that time unheard of) caused a storm when the picture was exhibited at the Glaspalast in Munich in 1890, leading one critic to comment: '... a glow of colour that even in these surroundings puts all others in the shade The two artists have even ventured to use gilding in the picture, and its effect is splendid, just because the work is so great and peculiar in its naivete [sic], so naïve a means can be applied with excellent effect.'

Interior – The Orange Blind, c.1927
Francis CB Cadell (1883–1937)
Oil on canvas
111.8 × 86.4 cm
Hamilton Bequest, 1928

Cadell's masterpiece, this painting represents a rather glamorized vision of the artist's spacious Georgian flat at 6 Ainslie Place, Edinburgh. The picture positively oozes period charm as the viewer is allowed to take part, unobserved, in the untroubled life of an elegant society lady as she enjoys her afternoon tea while listening to the piano being played. An air of mystery permeates the scene as the table is set for four – for whom is she waiting? And who is the mysterious man at the piano?

But anecdote aside, the picture is essentially a piece of visual seduction, all about light and colour. A visit to Cassis in the south of France in the early 1920s introduced into Cadell's art many of the elements of Fauve colour and composition that had earlier preoccupied his fellow Scottish Colourists, J D Fergusson and S J Peploe. Abandoning his earlier impressionistic style, Cadell now favoured a clearly defined technique based on precise flat brushwork and bold areas of strong colour contrasts.

Cadell delights in the spatial complexities of looking from one room through to another. No attempt is made to create the illusion of recession in the traditional sense. Instead he uses the geometry of different elements in the room – doors, windows, dados, screens, blinds – to build up a complex rhythm; the viewer is led from one element to another, with the orange blind providing a dazzling focal point at the heart of the picture. This gives the whole composition a nervous energy and zest so redolent of the Jazz Age of the 1920s. Reflections of light on floors, chandeliers and silver tea services are also very much part of the picture, partly because Cadell could never resist painting them, but also because they enhance the spatial complexities of the room.

For many, the great appeal of this picture must lie in its portrayal of a sophisticated, relaxed bygone era which is far removed from the realities experienced by most of us today.

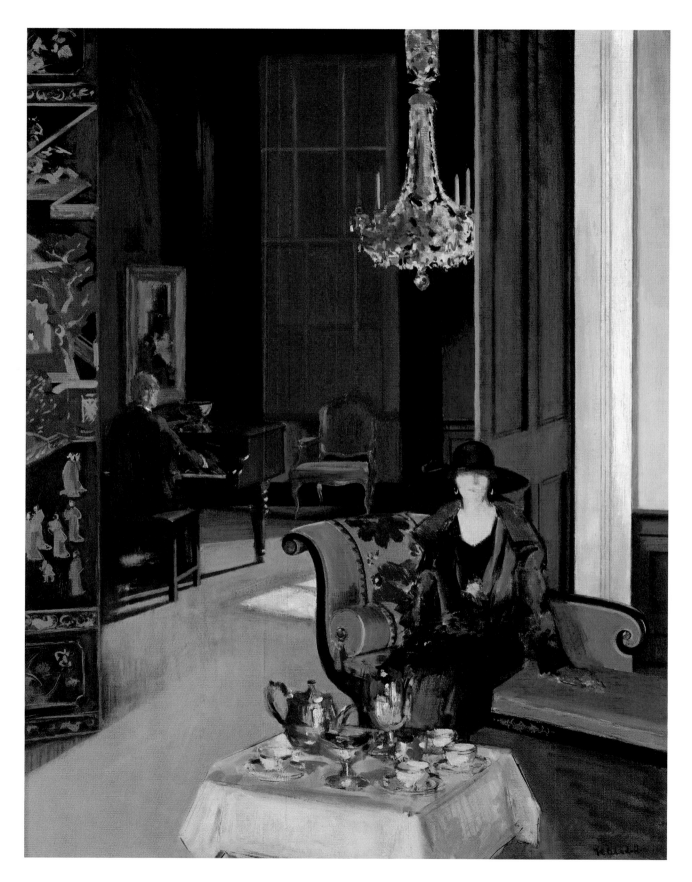

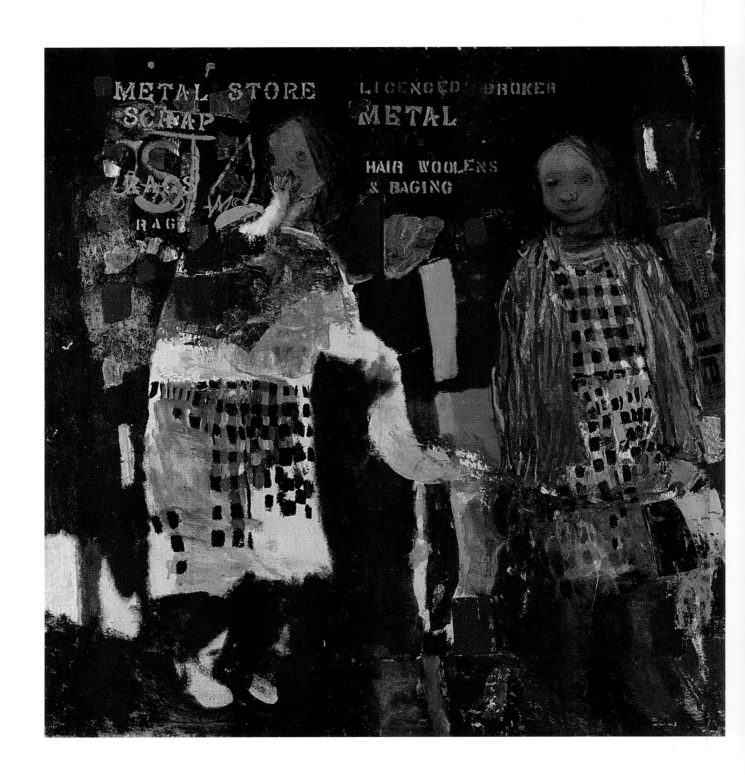

Two Children, 1963
Joan Eardley (1921–63)
Oil and collage on canvas
134.7 × 134.7 cm
Purchased 1994 with aid from the National
Fund for Acquisitions and Glasgow Art
Gallery and Museums Association Golden
Jubilee Appeal

Regarded by many as the most important artist in postwar Scotland, Joan Eardley was born in Sussex but came to Glasgow in 1939 and studied at Glasgow School of Art. She divided her time between her town and country studios. Her two principal themes were Glasgow children who played in the streets near her Townhead studio and the landscapes and seascapes around Catterline, an old fishing village she 'discovered' on the east coast about 1950.

In the 1960s she began a series of paintings based on the Townhead youngsters that were characterized by a restless energy. Often, the children were depicted against a vibrant red backdrop inspired by the metal store at the corner of St James's Road which had been given a coat of scarlet paint. *Two Children* was Eardley's last and most ambitious picture of the series and was found unfinished on her easel after her death at the age of 42 in 1963. This bold oil makes good use of pattern and colour and incorporates collage to depict the rough tenement walls plastered with graffiti. Eardley had found a set of old metal stencils and the stencilled letters – 'metal store scrap', 'hair', 'woolens & baging' – seem to dance over the heads of the two girls. To this she added the metal foil of sweet papers and newspaper headlines – the flotsam and jetsam of Glasgow street life.

The children are treated with freedom as part of the picture's overall pattern of line and colour, their summer clothes a mishmash of styles, patterns and colours, and their expressions difficult to read – has the taller one just put a sweetie in her mouth or has she seen something that has surprised or shocked her? The smaller of the two looks on in a more passive, subdued way. The rough, almost makeshift application of the various media seems in accordance with a sensitive understanding of the children's nature and their lives.

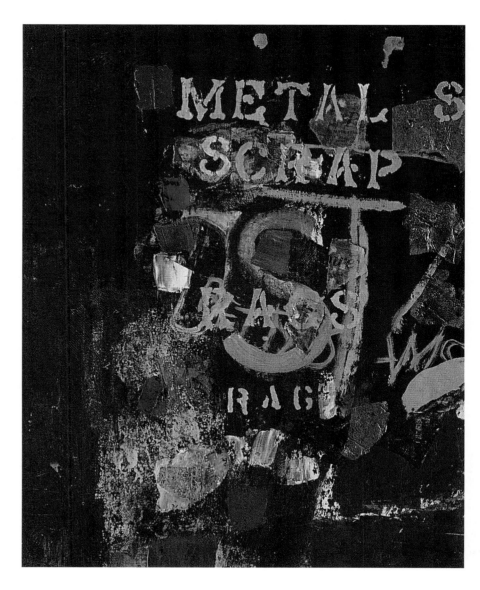

ITALIAN PAINTING

PAT COLLINS

St Lawrence, late fourteenth century
**Formerly attributed to Paolo di
Giovanni Fei** (active 1372–1410), Siena
Tempera and gold leaf on wood panel
62.9 × 31.1 cm
Gift of Lewis Lyons, 1980

This painting, dating from the late fourteenth century, originally formed part of a larger altarpiece. It would have been inserted in an elaborate gilded frame of gothic-arched form containing several similar panels with saints, as well as a larger scene in the centre. This main image may have been a Virgin and Child or a Crucifixion scene. St Lawrence, the saint on this panel, holds his attributes of a palm leaf (which indicates that he was martyred – that he died for his Christian faith) and a gridiron (which relates to the manner of his death – he is traditionally supposed to have been roasted alive). Legend also relates that Lawrence was a deacon in Rome, who was put to death in AD 258 when he refused to hand over valuable church treasures to a Roman official – instead, he offered up a group of poor and sick people, saying that they were the true 'church's treasure'.

This is the earliest painting in Glasgow's collection and represents the pre-Renaissance period. It features a background of real gold leaf, which conjures up a vision of heavenly light behind the figure. The halo around his head, emphasized by stamped decoration, indicates that the church rewarded Lawrence's sacrifice by making him a saint.

The work was originally gifted as the work of Paolo di Giovanni Fei, but recent research suggests that it may be by another Sienese artist of the time, Niccolò di Buonaccorso.

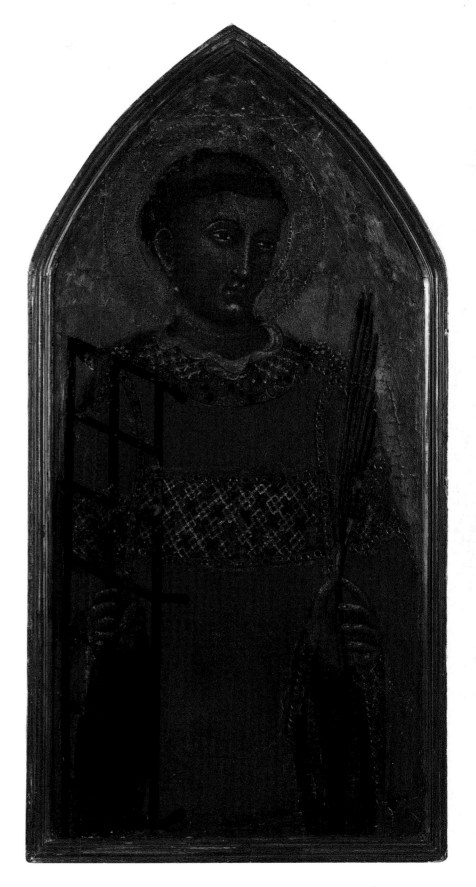

The Madonna and Child, *c*.1475
Giovanni Bellini (*c*.1431–1516), Venice
Oil on wood panel
62.2 × 46.4 cm
Bequeathed by Mrs John Graham-Gilbert, 1877

One of many images of the Madonna and Child by the artist, this was painted by Giovanni Bellini around the year 1475. It shows the Virgin Mary gently supporting Jesus, who is balanced on a marble balustrade running across the foreground of the picture. There are balustrades in many of Bellini's paintings of the Madonna and Child, simultaneously inviting the viewer to worship while maintaining an element of distance. Jesus holds up his right hand in the traditional gesture of blessing, and both he and Mary look down calmly towards the viewer, thus giving the impression that he or she is being blessed by the Christ Child himself. The painting has been much overpainted and badly cleaned in the past, but nonetheless the serenity of the image against the dark background is still most effective and beautiful. It was thought that the plain background might cover a landscape scene, as found in some similar works, but x-ray photographs show that there is nothing drawn or painted underneath the black layer.

Giovanni Bellini came from a dynasty of Venetian painters – his father Jacopo and his brother Gentile were both famous, as was his brother-in-law, Andrea Mantegna. He was one of the first Italian artists to make extensive use of oil paints, which gradually replaced the traditional medium of tempera (colour pigments mixed with egg). The rich colours of oil-based paints, together with their slow-drying qualities and translucency, enabled artists to produce brilliant yet subtly-modelled works of art which appeared more natural than the rather stilted works, enriched with gold, of the previous era. Venetian artists like Bellini and his pupils were particularly noted for their imaginative use of colour.

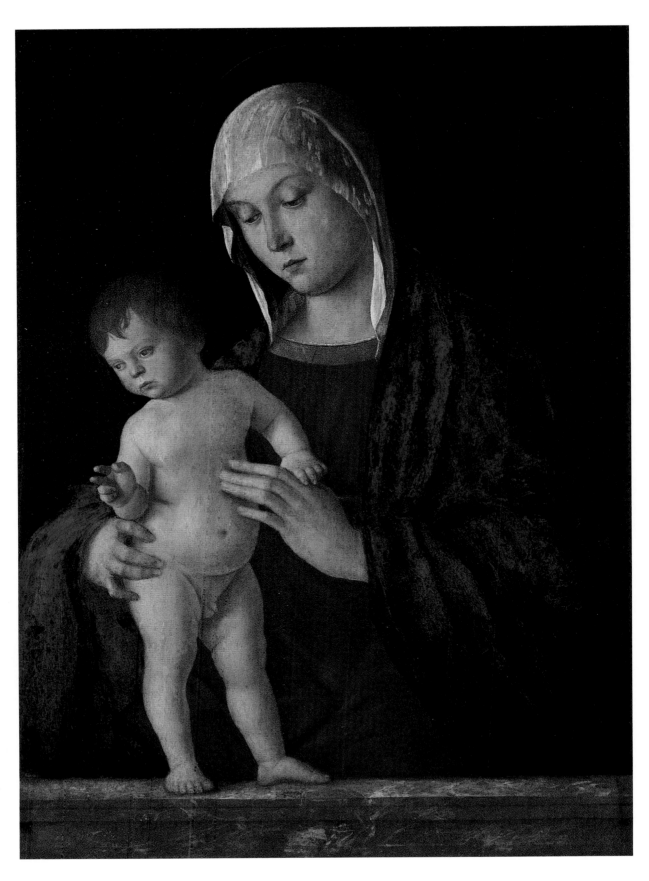

The Madonna and Child with the Infant St John the Baptist
and Two Angels, c.1485
Filippino Lippi (c.1457–1504), Florence
Tempera on wood panel
Diameter 118.4 cm
Gift of Mrs Mary Ann Walker, in memory
of her father, James Young, 1902

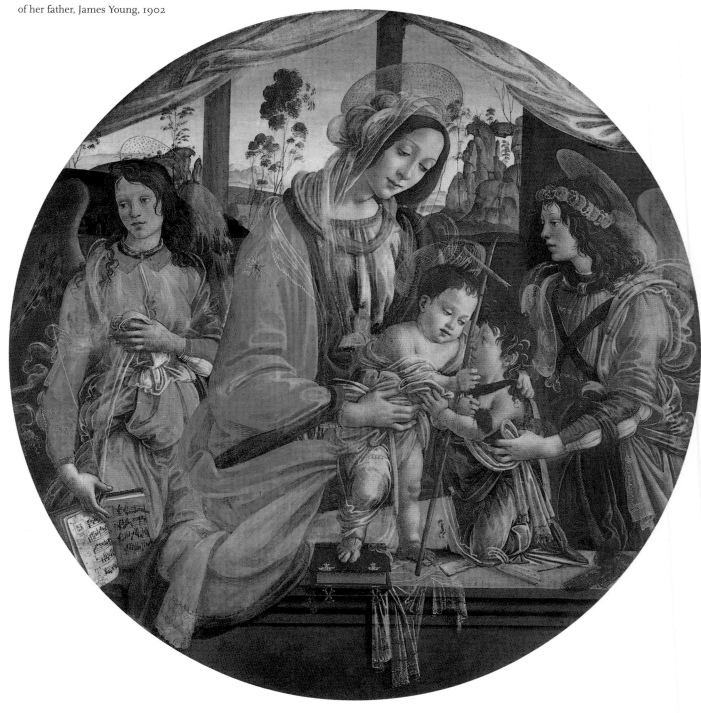

This beautiful painting from the mid-1480s is heavy with symbolism. Renaissance patrons admired artists who supplied religious paintings featuring layers of meaning. Meditating on these 'hidden depths' helped focus viewers' minds on the mysteries of the Christian faith and provided an effective aid to prayer. Even the form and materials which make up this work can be interpreted symbolically. For instance, the 'tondo', or round shape of the painting, relates to the circle as a perfect geometrical form which, because it has no beginning or end, often stands as a symbol of eternity – the eternal life promised to Christian believers.

Conventional Christian symbolism within the painting includes the three-light window, representing the Holy Trinity, and the rose garland around one angel's head, indicating the devotional ritual of repeated prayers known as the rosary. The central scene is more complex – Jesus embraces his cousin,

St John the Baptist (recognizable by his attributes of camel-skin robe and cross), who kneels and gazes up in wide-eyed wonder. This group prefigures the act we know will take place years later, when John, about to baptize him, recognizes Jesus as the Messiah. Here the young Jesus grasps John's cross, symbolically accepting the painful fate that awaits him. The closed book under Jesus's foot represents the Old Testament; the music manuscript – although not 'proper' music – adds a further dimension to the image. This may suggest a sung biblical quotation relating to St John's role; perhaps 'And thou, child, shalt be called the prophet of the Highest: for thou shalt go before the face of the Lord to prepare his ways' (St Luke, 1:76).

James Young, the Glaswegian father of the donor, was a pioneer in the field of petrochemical science, and made a fortune from the manufacture of paraffin.

The Annunciation, c.1500
**Alessandro Filipepi, known as Sandro
Botticelli** (c.1445–1510), Florence
Tempera on wood panel
49.5 × 61.9 cm
Bequeathed by Archibald McLellan, 1854

This is one of several versions of the
Annunciation painted by Botticelli.
It dates from about 1500. The
archangel Gabriel arrives on earth and
rushes in to inform Mary that she will
give birth to Jesus, the Son of God.
Mary accepts this news humbly, her
head bowed and an arm gently placed
across her breast. Golden rays shoot
across the picture – they represent
God's Grace approaching the young
Virgin.

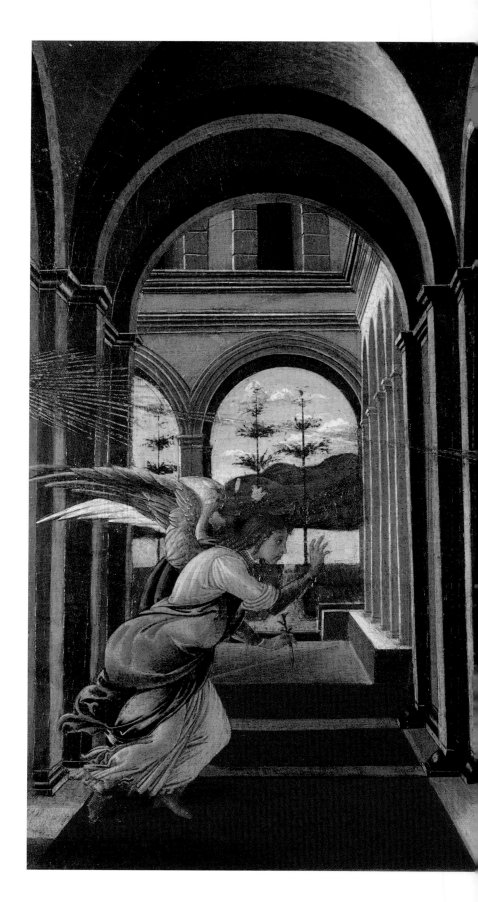

This painting is a near-perfect example of all that characterizes Italian Renaissance art. The architecture shown here is in the style current in Florence in Botticelli's day and would have been familiar to all Florentines of the time – a series of rooms and loggias (open-sided galleries) set around an arcaded courtyard. This setting provided Botticelli with the perfect opportunity to show off his skill at depicting three-dimensional space on a flat surface, using the recently perfected art of mathematical perspective. From the massive central foreground pillar, the horizontal lines of the architecture and geometric floor pattern appear to recede back to a single vanishing point, placed just above Gabriel's head. Notice also how the golden rays disappear behind the central pillar and then reappear, adding to the illusion of depth. The complex task of continuing the appearance of spatial recession accurately on the right-hand side of the painting is fudged – Botticelli has cleverly placed a wall across the arched space to the side of the Virgin Mary!

According to an old inscription on the reverse, this painting may once have been connected with a church dedicated to St Barnabas in Florence. Because of its fragility, the work is displayed within a frame containing devices that monitor the conditions immediately surrounding it.

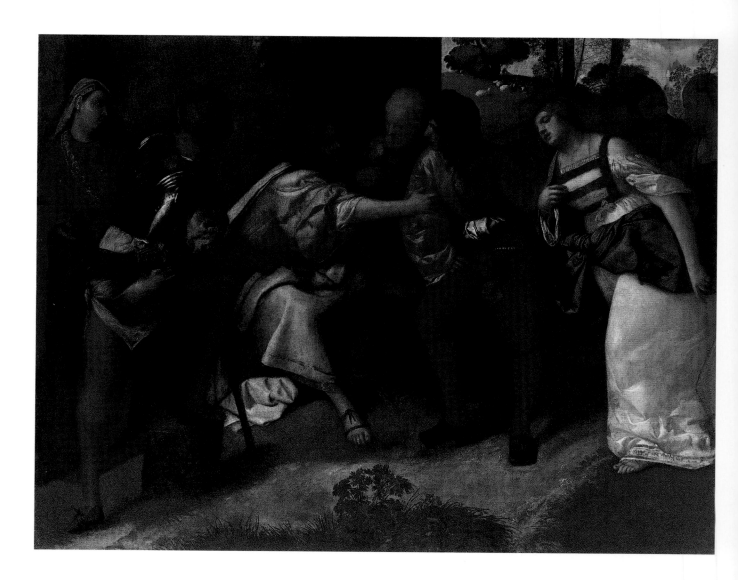

The Adulteress brought before Christ,
*c.*1510, and ***Head of a Man***, *c.*1510
Giorgio da Castelfranco, known as
Giorgione (active 1506, died 1510)
and/or **Tiziano Vecellio**, known as
Titian (*c.*1490–1576), Venice
Oil on canvas
139.2 × 181.7 cm (*The Adulteress*);
47.0 × 40.5 cm (*Head of a Man*)
Bequeathed by Archibald McLellan,1854
(*The Adulteress*); purchased 1971 (*Head of
a Man*)

These two images once formed part
of the same painting. A copy of the
original work (see illustration opposite)
in the Accademia Carrara, Bergamo,
shows how it once looked. However,
the right-hand male figure has been
cut off, and his head framed to make a
separate picture (you can just see his
knee, wearing striped hose, on the far
right-hand side of our picture!).

This work – the most important
picture in Glasgow's Italian collection
– has been attributed to various
Venetian artists over the years. During
the seventeenth century it was in the
collection of Queen Christina of
Sweden, where it was attributed to

Giorgio da Castelfranco, better known
as Giorgione. Giorgione was a highly
acclaimed artist who died young,
leaving very few documented paintings.
However, over the years his authorship
of this work has often been questioned
by scholars, and nowadays it is
generally thought to be by the slightly
younger artist Tiziano Vecellio, known
as Titian. Titian knew Giorgione and
worked with him for a few years, and
we know he produced work in a style
imitating that of the master. Giorgione
was particularly renowned for
introducing a sense of mystery in his
paintings, often making use of *sfumato*
(the softening of outlines) and shadowy

light effects. Examples of these characteristics can be seen here, but it is also worth noting that many of Titian's known works contain details which compare very closely indeed to particular aspects of our painting.

The scene (from St John, 8) shows the moment when scribes and Pharisees bring an adulteress to Christ at the Temple and ask him what her punishment should be – should she be stoned as had been commanded by Moses? Jesus's famous reply 'He that is without sin among you, let him first cast a stone at her' greatly embarrassed those present, and Jesus let the woman go free after advising her to 'sin no more'.

The artist has emphasized the relationship between the principal figures by means of poses and hand gestures – forming a kind of linked chain across the main space. They also interchange meaningful glances, and are clearly deep in discussion – except for the accused woman herself, the object of it all, who stands meekly, looking down humbly in contrition. Colour, too, plays an important role in the composition; areas of red, together with its opposite on the spectrum wheel, green, enliven the scene with clarity and contrast – Venetian artists at this time were often praised by contemporaries for their masterly use of vibrant colour. The elaborate drapery of Christ's sleeve and that of the young man next to him, the adulteress's green satin sash and the soldier's reflective metal breastplate all demonstrate the versatility and virtuosity of the artist who painted this work – whoever he may have been!

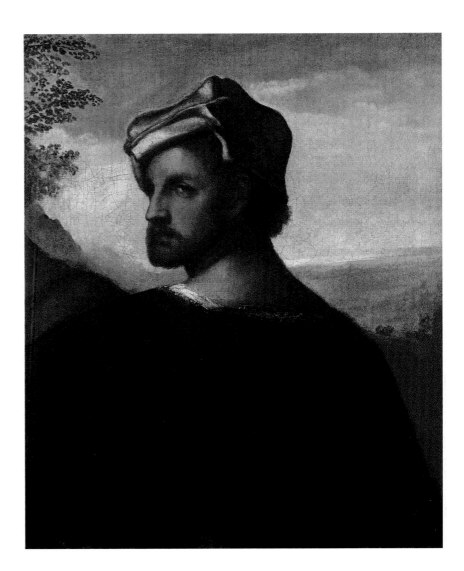

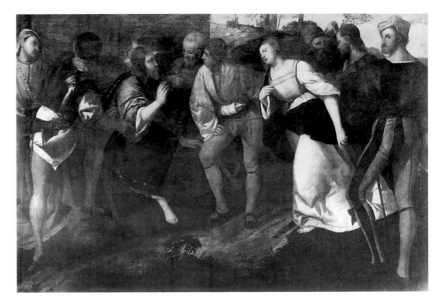

The Archangel Michael and the Rebel Angels, *c.*1592
Guiseppe Cesari, called il Cavaliere d'Arpino (1568–1640),
Rome
Oil on copper
57.8 × 41.8 cm
Bequeathed by Archibald McLellan, 1854

Several versions are known of this painting, which dates from about 1592. It shows the Archangel Michael driving out from Heaven the rebel angels who refused to oppose their fellow angel-turned-to-the-bad Lucifer (also known as Satan or the Devil). It is finely painted with oil colours on copper sheet, a technique that produces a delicate jewel-like finish.

This work exhibits many of the typical characteristics of the refined style of later Renaissance art known as Mannerism. The figures of the tumbling angels, shown in various complex and expressive poses, show off the artist's masterly skill in depicting anatomically correct nudes. One of St Michael's legs, too, is dramatically foreshortened for effect as he swoops down from the light of Heaven to the darkness of Hell beneath,

sword in hand. At one time this leg was painted out, and a substitute limb was added in a more conventional position; the nudes also had modesty-covering serpents entwined around their bodies at some stage. These overpainted additions were removed in the 1960s.

The dramatic effect of the work is underlined by St Michael's costume. He wears a fanciful and elaborate version of Roman armour, of the type that would have been worn by actors in the contemporary theatrical productions known as masques. His weapons, though, look real enough for their purpose. Paintings like this one helped to reinforce the spirit of renewed optimism in the Roman Catholic Church in the post-Reformation period.

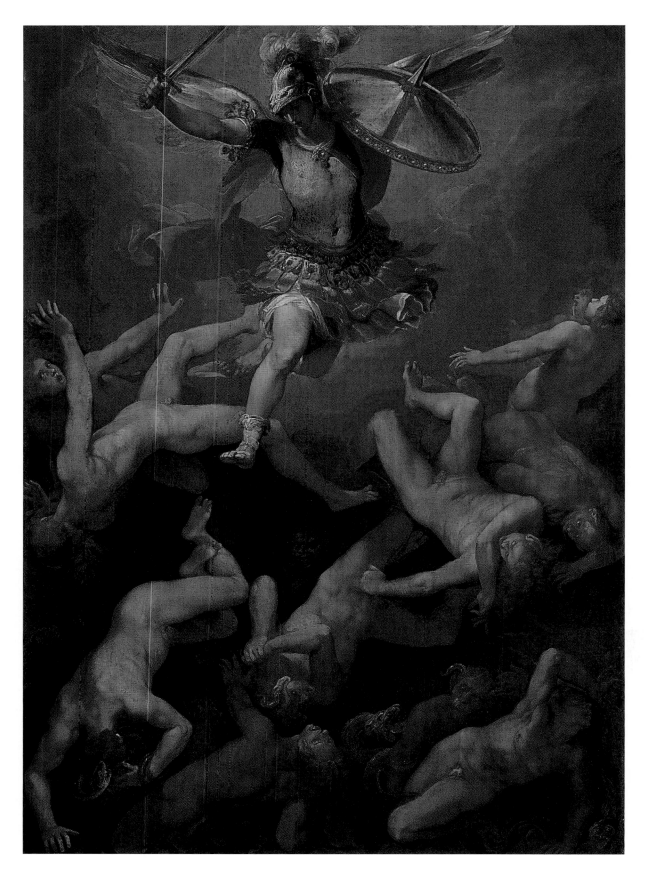

Landscape with St John the Baptist
Pointing Out Christ, 1655–60
Salvator Rosa (1615–73)
Oil on canvas
173.4 × 260.7 cm
Presented in memory of John Young by his family, 1952

Glasgow is privileged to own the best two works in the British Isles by Salvator Rosa, this painting and its companion piece *Landscape with the Baptism of Christ*. Both were presented by the descendants of James Young, the Scottish businessman and art collector known as 'Paraffin Young' because of his role in the development of the shale oil industry. They were brought to Scotland for him in 1877 from Florence, where they had been in the possession of the noble Guadagni family since the middle of the seventeenth century. Even the stern critic John Ruskin gave them grudging praise when he viewed them in the Guadagni Palace in 1845, and the local press was alarmed and disapproving when a foreign buyer was able to secure such masterpieces so cheaply.

We see St John the Baptist indicating to a group of men the lonely figure of Jesus Christ, who has been sent into the wilderness by God to undergo hardship and temptation as a test of strength before starting his years of teaching. The rocks and trees, however, dominate the action. The fierce diagonal of the skyline, the strong contrast of the billowing clouds in the sky and the contorted shapes of the trees provide a dramatic setting for the moment when the future Saviour of the World is identified to man.

Few other landscapes combine such grandeur with so many passages of detail of great beauty. Rosa was one of the first to paint landscapes in their own right. They are works of a vivid imagination. His is a romantic vision of untamed nature, much admired in eighteenth- and nineteenth-century Britain, where he was given the title 'Savage Rosa' and his work was described as 'sublime'. H S

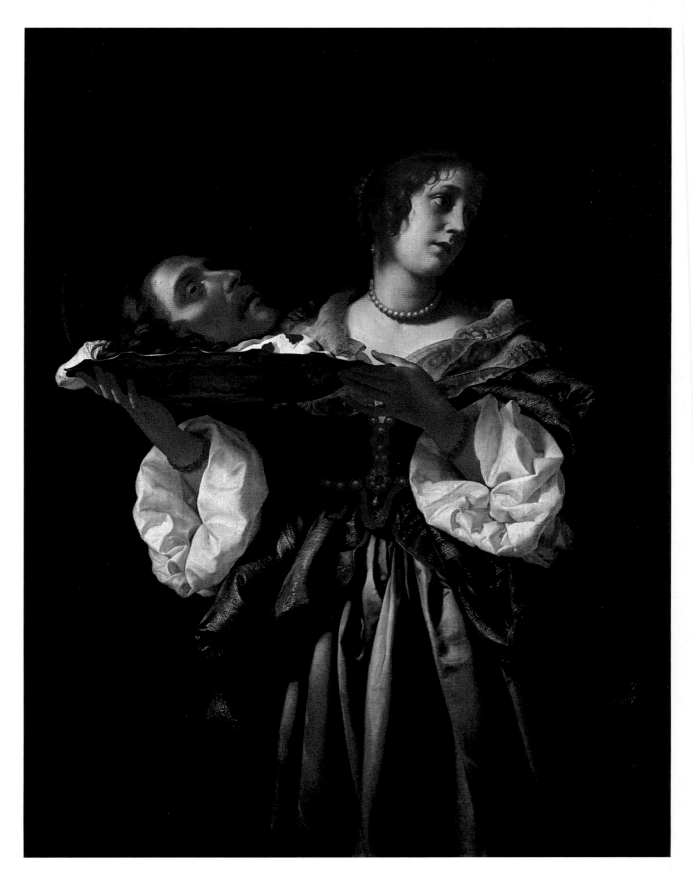

Salome with the Head of John the Baptist, c.1680
Carlo Dolci (1616–86), Florence
Oil on canvas
123.1 × 95.3 cm
Purchased 1883

Painted in about 1680, this is one of several versions of a popular work by Dolci which was originally paired with an equally gory scene depicting David with the head of Goliath. Events leading up to this scene can be found in the Bible in St Matthew, 14. Salome's mother married her brother-in-law, the Jewish King Herod, but after John the Baptist condemned this relationship as bigamous the king imprisoned him. When Salome danced for the king at his birthday feast, he promised her whatever she desired. Prompted by her mother, Salome asked for John the Baptist's head on a dish. John was executed, and Salome carried his head to her mother in triumph.

Dolci was a deeply religious artist, whose paintings were intended – perhaps surprisingly to modern eyes – to inspire piety in their viewers. His early large altarpieces were to a great extent replaced by studies of striking single figures like this one, dramatically lit characters against a plain background who confront us boldly. The lighting, facial expressions and beautifully executed costume and accessories invite close examination of the work, while the prominent head of St John invites contemplation of its meaning. Here, the sumptuously overblown and bejewelled dress of Salome is used to indicate the decadence of the people responsible for the death of the innocent, saintly prophet. Salome's glance across the picture space is not triumphant, but thoughtful, as if she herself has just become aware of the potential enormity of her actions. The accompanying painting of David with the head of Goliath would complement this image 'in reverse' by depicting a righteous figure holding the head of an evil one.

***View of the Church of San Giorgio
Maggiore, Venice***, *c.*1755
Francesco Guardi (1712–93), Venice
Oil on canvas
71.1 × 119.7 cm
Bequeathed by Archibald McLellan, 1854

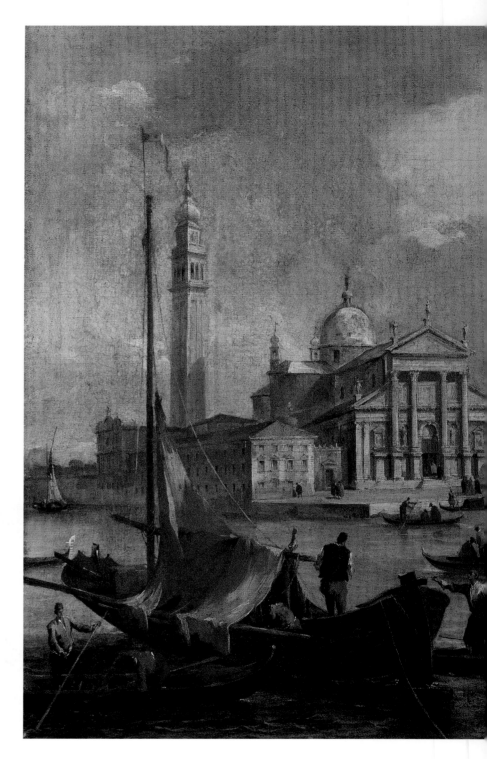

Painted between 1750 and 1760, this atmospheric work depicts a view across the basin of St Mark's to the Island of San Giorgio. The magnificent church of the same name that dominates the skyline was designed in 1565 by one of the foremost architects of the Renaissance period, Andrea Palladio. In the foreground are working boats and gondolas with their busy crews, skimming across the glassy water. These are all carefully arranged by the artist to provide an attractive and rhythmic approach to the island and the misty open waters of the lagoon beyond. Guardi painted this same view several times, but experimented with different arrangements of boats in each one.

Guardi, together with Antonio Canale (better known as Canaletto), supplied a steady stream of superb images depicting the supremely picturesque city of Venice for the high-class tourist market of the time. Venice was one of the 'must-see' cities visited by young aristocrats and well-to-do families on their Grand Tour of Europe, and paintings were among the favourite souvenirs

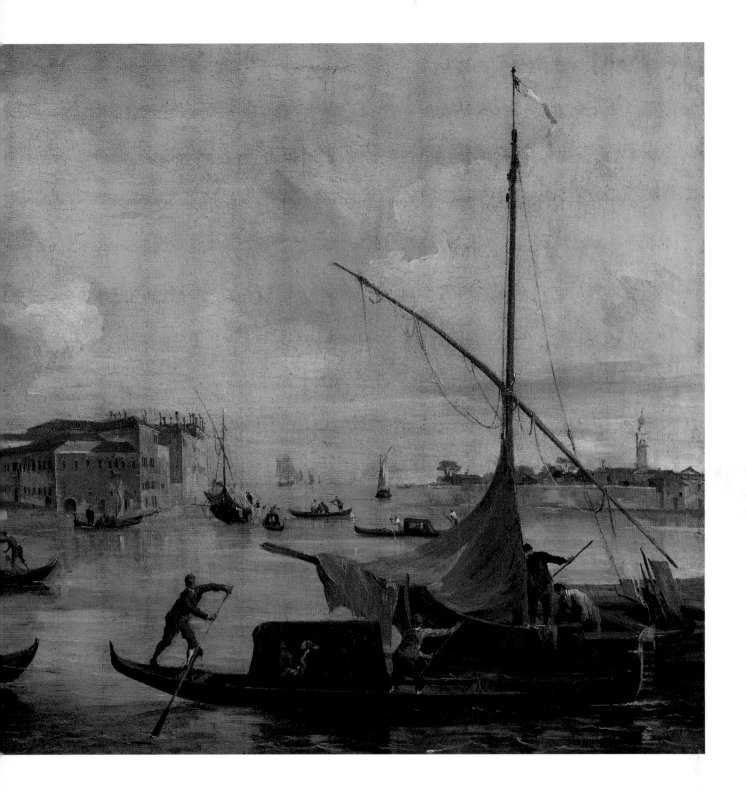

purchased or commissioned during their stay. It is interesting to compare works depicting Venice by Guardi with those by Canaletto. The former's free – almost impressionistic – handling of paint, as here, conveys what might be called the 'spirit of the place', whilst Canaletto, using tighter outlines, seems to have sought to reproduce a more detailed appearance of visual reality.

Dutch and
Flemish Painting

Hugh Stevenson

St Maurice (or St Victor) with a Donor,
c.1480–c.1500
The Master of Moulins (active *c.1480–c.1500*)
Oil on wood panel
58.4 × 49.5 cm
Bequeathed by Archibald McLellan, 1854

This painting is one of only two works in Britain by one of the outstanding artists of the late Gothic period, who was active in the town of Moulins in the Bourbon area of central France. It is believed to have been the right-hand panel of a diptych (a small, hinged, two-part altarpiece). The warrior saint is shown presenting the donor, a high churchman; the left-hand panel, now lost, would have represented the Virgin Mary and Child Jesus. The donor's splendid gold brocade cope and jewellery show that he is a rich man. The patron saint, either Maurice or Victor, in whose breastplate the churchman's features are exquisitely reflected, may serve to identify him or the religious establishment with which he was connected. The gold *fleur de lys* devices on the warrior's red shield and on the fluttering pennant may give a further clue, but scholars have so far failed to come to agreement as to who he is.

The mystery is intensified by the problem of the identity of the Master. A series of hauntingly beautiful works executed in a highly detailed, polished style has been connected with him, based on their similarity to his painting of the high altarpiece in the cathedral of Moulins. Arguments continue unresolved as to whether he was a certain Jean Hey or Jean Prevost, a stained glass artist in Lyon, or Jean Perreal of Paris. The influence of the great Flemish fifteenth-century painters is so strong in the work of the French Master that it is assumed that he received his art training in Flanders, perhaps in Bruges or Ghent.

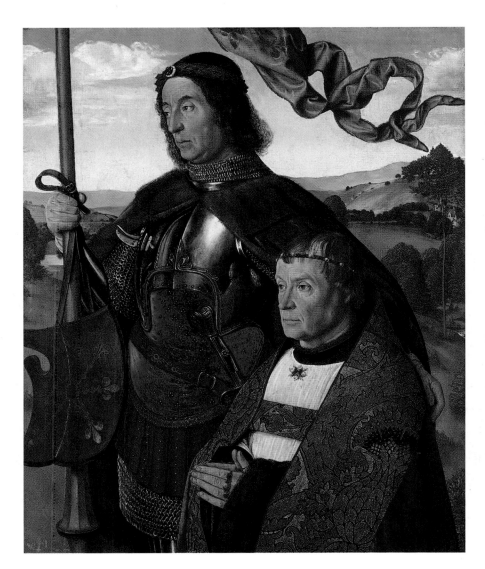

The colours are still fresh and vibrant today, a tribute to the skill of the Master. The great Glasgow collector Archibald McLellan bequeathed the picture to the Gallery in 1854, but, as if to add to the mystery, it is not known where he acquired it.

Maidservant with a Basket of Fruit
and Two Lovers, c.1635
Jacob Jordaens (1593–1678)
Oil on canvas
119.6 × 157.1 cm
Bequeathed by Archibald McLellan, 1854

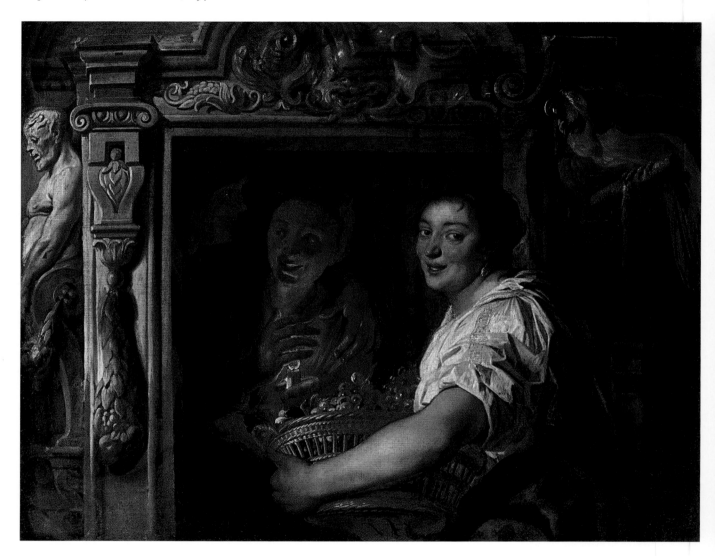

Jordaens was the major painter in Antwerp after the deaths of Rubens and Van Dyck. He was a master of grand compositions in the manner of Rubens and adopted his love of pearly flesh tones, but also liked to portray the lives of everyday people. He revelled in creating dramatic light effects, a practice that was popular in Northern Europe, though initiated in Italy by Caravaggio. His interest in the complexities of showing two separate light sources is clearly evident here.

The picture has been known traditionally as *The Fruit Seller*, but this is inaccurate. It is a preparatory painting for one of a series of tapestries woven in Brussels showing scenes from country life. A complete set is in the Kunsthistorisches Museum in Vienna. These were made from designs (or 'cartoons') prepared by Jordaens. He changed his mind about this composition, as is noticeable in the relief carvings of the Renaissance-style door surround. The two lovers were originally framed within a window, but Jordaens later widened and lengthened this to become a doorway. His overpainting has turned transparent through time, so that the carvings over the doorway are difficult to understand.

The picture has a deeper meaning than meets the eye. It may be about day and night or love and physical attraction. The face of the rustic servant looks so similar to that of the young woman in the shadows that the scene in the doorway may represent a 'dream of love' in her imagination. Grapes, as seen in her basket, are often seen as the food of love, while the carving on the left column is of a satyr, a creature half-man and half-goat, known for its virility. The candle surely alludes to the fleeting nature of love. The exact meaning, however, is not clear, as the parrot can be seen both as a sensual creature and as a symbol of fidelity within marriage.

A Man in Armour, 1655
Rembrandt Harmensz van Rijn
(1606–69)
Oil on canvas
137.5 × 104.5 cm
Bequeathed by Mrs John Graham-Gilbert,
1877

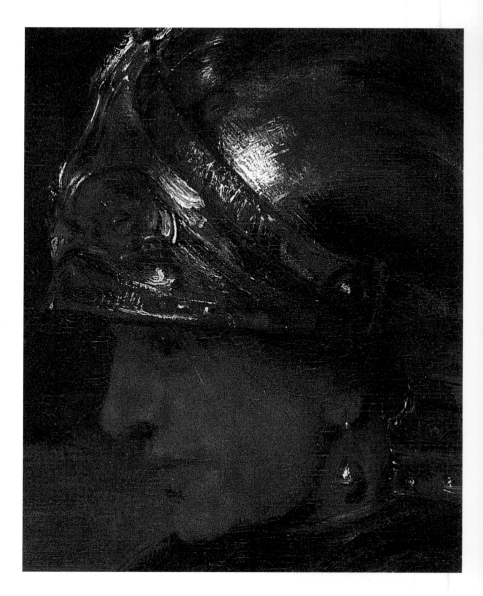

Considered as one of the master-
pieces of the collection ever since
it was received from the bequest of the
widow of the Glasgow portrait painter
John Graham-Gilbert in 1877, *A Man in
Armour* has excited admiration and
scholarly discussion in equal measure.

Painted in Amsterdam, where
Rembrandt ran a large studio, it was
probably intended to be sold to a rich
patron. The half-length figure wears
armour largely based on types found in
the Netherlands in the seventeenth
century and holds a lance and a shield.
Rembrandt was fascinated by finely
crafted armour, amassed his own
collection of such items and frequently
depicted them in self-portraits and in
large single figure compositions.

The effects of light on different
surfaces, although achieved with a
limited range of colours, are a source
of wonder in this picture. The way the
warrior looms up against a mysterious
background makes a powerful
impression. Unlike most of his
contemporaries, the 'fine painters'
(*fijnschilders*), Rembrandt and his
workshop preferred to create effect by
a broad sweep of the brush, leaving the
viewer to enjoy the texture of the paint
as well as the surfaces it was intended
to portray. This is the real joy of this
painting.

Rembrandt changed his mind several
times while working on this picture; he
was constantly experimenting. There is
much discussion as to whether he or a
later artist added the four strips of
canvas which are made visible by their
slight difference in colour around the
sides of the composition.

It has been suggested that the man
may represent a character from ancient
history or mythology, such as Mars, the
God of War, Achilles, the Greek hero,
or the ancient Macedonian warrior
king, Alexander the Great. The heroic
pose suggests someone important, but
there are not enough attributes to act
as positive clues, only the hint of an
owl's head at the front of the helmet
and the pearl drop earring worn on the
left ear. What is never in doubt is that
this is a true example of Rembrandt's
genius at the height of his powers in
the 1650s.

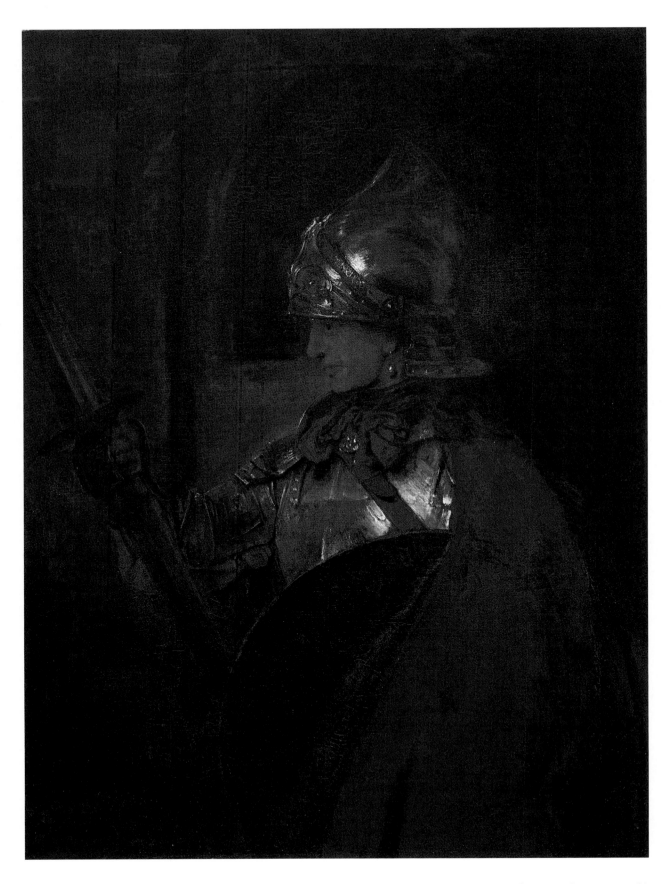

A Surgeon Treating a Peasant's Foot,
*c.*1650
David Teniers II (1610–90)
Oil on wood panel
36.8 × 27.3 cm
Bequeathed by Archibald McLellan, 1854

This is a fine example of low-life genre painting, which was very popular in Flanders and the Netherlands in the seventeenth century. It gives an excellent insight into the daily lives of the peasantry: their domestic arrangements, clothing and furnishings. The woman warms a dressing over charcoals in a terracotta bowl in the sparse 'surgery'. It is not clear what potions the better-dressed surgeon is using. Many unqualified quack doctors operated at the time.

Teniers painted in Antwerp and Brussels, producing a large body of paintings. He was so popular that he was much imitated. British collectors were particularly fond of his work. The great Scottish merchant and speculator Sir Lawrence Dundas MP owned 14 so-called Teniers paintings and bought this one from the dealer John Greenwood in 1763 for 36 guineas. It was later acquired by Archibald McLellan, who bequeathed it to the citizens of Glasgow. It is one among 17 works catalogued under the name of Teniers, only about five of which are accepted today by scholars as being from the master's hand. The freshness of the brushwork, the ease with which the poses of the figures are described and the ability to create character in the faces in this painting mark it as an original Teniers.

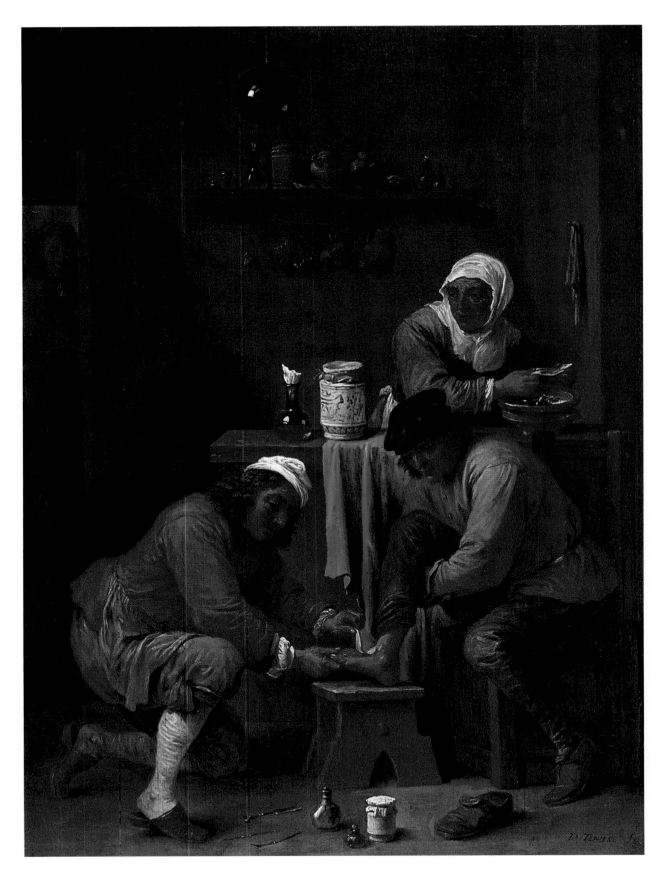

The Five Senses, 1668
Gerard de Lairesse (1641–1711)
Oil on canvas
137.2 × 182.9 cm
Purchased with grants from the Heritage Lottery Fund, the National
Art Collections Fund, and the Hamilton Bequest, 2001

In this elaborate composition the senses are represented by the five main figures and by other elements scattered throughout the picture. Thus the little boy in the foreground pointing to the mirror symbolizes Sight. Hearing corresponds to the other boy playing the triangle, but also to the flute, the musical scores and the shells (in which one might listen to the music of the sea) on the marble step, lower right. Taste is represented by the woman on the right, holding a peach, by the platter of fruit and by the little monkey, almost hidden on the right, which is filling its mouth with pieces of fruit.

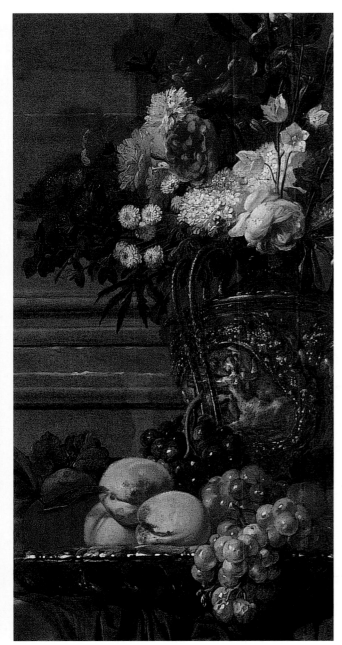

creating mural decorations and large paintings for the town houses of the rich. The classical architectural setting for this work was deliberately included to appeal to the taste for classical antique art, which swept through fashionable Dutch society towards the end of the seventeenth century. Lairesse was a high-minded artist, who considered still life to be 'an aid for the weaker minds' but accepted that it had merit if it contained hidden meaning. Clear stylistic differences suggest that he may have employed a specialist artist to paint the sumptuous vase of flowers and the fruit.

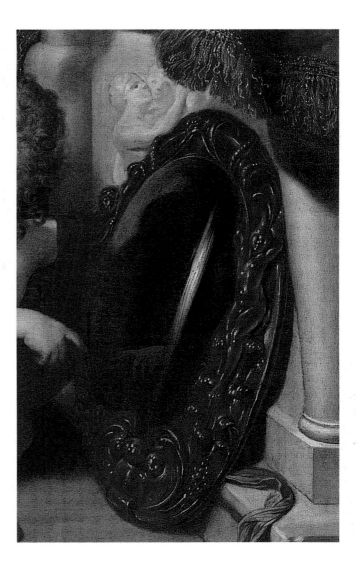

Smell is shown by the roses held by the girl in the centre and by the large vase of flowers. Finally, Touch appears in the form of a woman holding aloft a parrot that pecks at her finger; the snail on the pedestal, lower left, also represents Touch, as it retracts into its shell at the slightest contact.

The theme of the Five Senses was a popular one in Northern European painting, but here it is given lavish treatment – almost everything in the picture is meant to appeal to the senses. Although Lairesse was born at Liège in present-day Belgium, he settled in Amsterdam, where he earned success

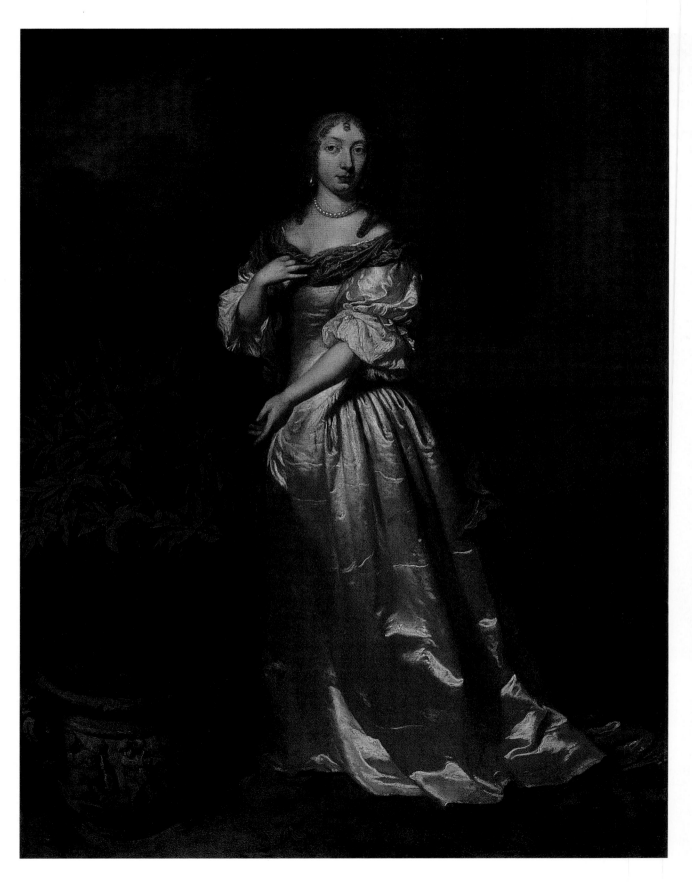

A Woman in a Satin Dress, 1668
Caspar Netscher (1639–84)
Oil on canvas
86.7 × 67.9 cm
Bequeathed by Archibald McLellan, 1854

This picture is one of the few in Glasgow's collection that was painted in The Hague, where Netscher settled in 1662. Although Amsterdam was far larger and economically and culturally more significant, The Hague was politically the most important city in the Dutch state. It was the home of the House of Orange, which became the virtual monarchy of the Netherlands. The unknown lady who is the subject of this portrait points towards a small orange tree, which probably indicates her loyalty to the House of Orange.

Netscher was in great demand in court circles as a portraitist. His sitters were the wealthy and fashionable, and judging by this lady's dress, she was no exception. It is an unusually large work for Netscher, who normally painted small, half-length portraits, but it is still of a comfortable size to have been displayed in a domestic setting.

The lady is shown in a graceful pose, which derives from classical statuary. The grand composition, with background columns and an urn with cherubs reflecting ancient Roman culture, suggests that she was of some importance. Her beautiful, shimmering satin dress and elegant coiffure enabled the artist to show off his skill in the creation of high finish, a style of painting known at the time as 'fine painting'. Towards the end of the seventeenth century the influence of international style and sophistication became increasingly evident in the Netherlands. This development was perfectly captured in Netscher's exquisite portraits. Although accomplished and highly successful in his time, he was neglected by later historians, as it was felt that his work represented the decline of Dutch art, away from the hearty egalitarian flavour of the art of the earlier part of the century.

A View of Egmond aan Zee, *c.*1647/8
Jacob Isaacsz van Ruisdael (*c.*1628–82)
Oil on wood panel
49.8 × 68.3 cm
Bequeathed by Archibald McLellan, 1854

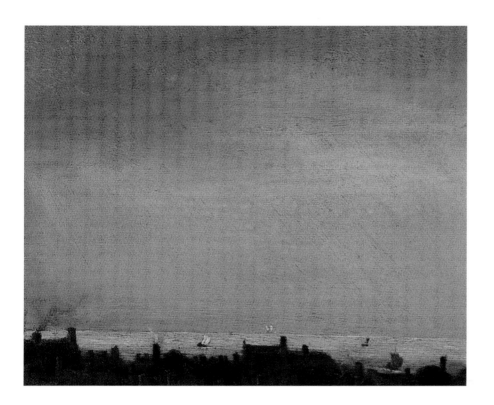

This Dutch town, situated on the North Sea coast, west of Alkmaar, provided the young Ruisdael with much of his subject matter. He lived then in Haarlem, but Egmond must have been a favourite with potential buyers of his work. At least six of his paintings of the town survive today. The main feature, the church tower, was already damaged when the artist painted it, and its last remains finally fell in 1743.

The greatest of all Dutch landscape painters of the Golden Age in the seventeenth century, and one of the greatest of all time, Ruisdael was noted for his skies. The effect of the clouds brooding over the dunes, as here, and the shadows cast on the buildings create a mood of rustic grandeur.

There is a solemn dignity to the whole scene; the buildings suggest that this is a place of honest toil, and the small figures moving around the foreground reinforce this impression. Ruisdael succeeds in creating a superb effect of changing weather, with the rays of an evening sun mixing with the threat of a shower of rain. He responds with feeling to the moods of nature in a direct manner with brushwork that is workmanlike – never slick, flashy or even beautiful. This quality endeared him to landscape painters of the eighteenth and nineteenth centuries in Britain such as Gainsborough, Constable and the Norwich School and also in France, particularly the members of the Barbizon School.

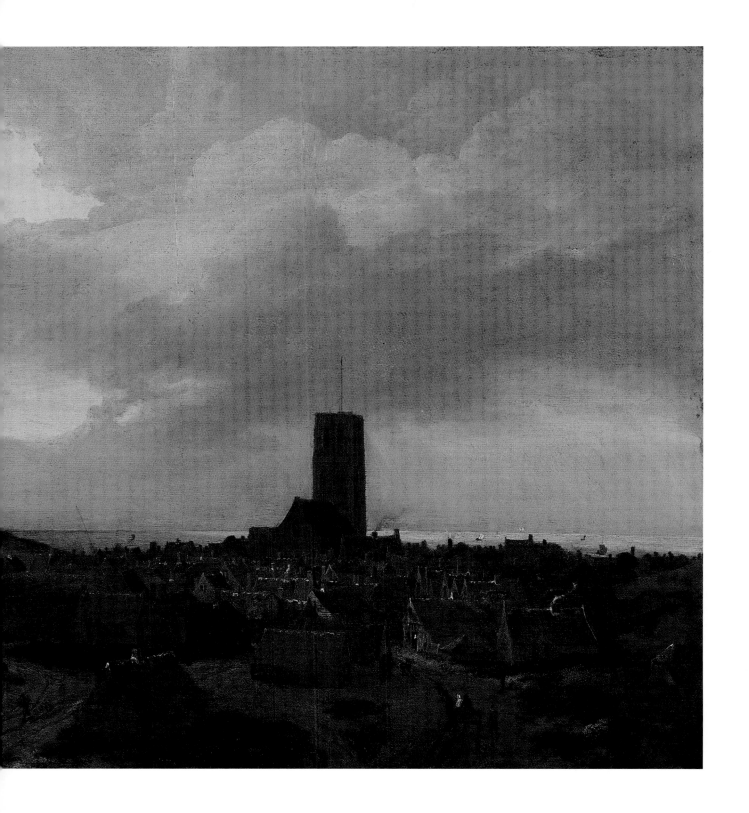

Still Life, 1680
Willem van Aelst (1627–c.83)
Oil on canvas
50.2 × 42.5 cm
Bequeathed by Mrs C Douglas of Orbiston,
1862

Of all the Dutch still-life paintings in the Kelvingrove collection, this is surely the most perfect. Van Aelst, a native of Delft who spent his most productive years in Amsterdam, was one of the best practitioners of this category of art. His careful technique and his shiny surfaces earned him the name of 'the aristocrat of still life'. This example has survived the ravages of time so well that it can be enjoyed almost as much as the day it was painted. When it was cleaned in 1975 the date 1680 could be read after the signature.

This is a typical still life of the popular type known as *ontbijtje* in Dutch (normally translated as 'breakfast-piece', although it does not consist of food that we would consider usual for breakfast). On a marble tabletop draped with a curtain are a large, bulbous, half-full wineglass known in Dutch as a *roemer* and a fancy Venetian-style glass. A gutted, sliced herring and its soft roe lie on a pewter plate. A small loaf, cherries and salad onions complete the scene. Each surface has been observed with precision. The subtle purplish-grey curtain invites us to touch the soft velvet of the fabric, while the crisply handled reflections on the glass reveal the individual windowpanes of the room where the picture was painted.

Paintings such as this epitomize the wealth and comfortable life styles of the middle classes of the time. For long considered the lowest level of art (well below heroic history painting), still life was raised to a high level by the skill of the Dutch painters. The word *stilleven*, translated into English as 'still life', was first noted in 1650, so the Dutch can be credited if not with the invention, then certainly with the perfection of the art.

After the McLellan Galleries close, works in the *Art Treasures of Kelvingrove* exhibition can next be seen in summer 2006, at the refurbished Kelvingrove Art Gallery and Museum.

DECORATIVE ART
ALISON BROWN

Chair, 1870
Christopher Dresser (1834–1904)
Made by Coalbrookdale, Shropshire,
England
Cast iron, oiled oak
Purchased 1980

Christopher Dresser advocated a return to the fundamental principles of design – truth to materials and to form. In his quest for creating a truly modern style he held ornamentation in the highest regard, claiming in 1871 that it is '... even a higher art than is practised by the pictorial artist, as it is of a wholly mental origin'.

This chair clearly demonstrates Dresser's design preoccupations, for the medium of cast iron serves his concerns well. The chair is cast in four separate sections, two sides, one back, and a small stretcher for the legs. The construction bolts that hold these sections of the chair together become part of the decoration itself, and their presence is balanced in the design by the inclusion of two fake bolts, positioned above the front legs immediately under the wooden seat. Ornamentation is integral to the chair's design; the back and legs are cast into shapes of scrolled geometric plant and flower forms, and these shapes and flat surfaces are in turn decorated by incised lines and zig-zags. The roundel in the centre back of the chair was designed by James Moyr Smith who worked in Dresser's studio during the 1860s and 70s.

Dresser designed for Coalbrookdale from 1867–72, thirty years after the foundry reinvented itself by employing designers to produce ornamental castings and furniture. Coalbrookdale had been one of the most important companies of the British Industrial Revolution, producing the first cast-iron bridge in 1779. Victorian cast iron furniture was cheap to produce, but went out of fashion *c.*1880, probably due to its unwieldy nature, which therefore limited where it could be used in the home; for example, this chair weighs in at 40kg (88lbs).

Mirror, c.1896
Frances Macdonald (1873–1921)
Beaten tin over a wooden frame, with mirrored glass
73 × 73.6 cm
Presented by Mrs Alice Talwin Morris, 1939

The decoration of this mirror frame contains the characteristic motifs of human figures and stylized plant forms that populate Frances Macdonald's early work. The honesty plant is the focal point of the frame's design. Growing from a seed located centrally in the lower half of the frame, the stalks, leaves, and flat round seed pods of the plant encircle the central mirror. The two flower heads are positioned alongside the heads of two androgynous human figures that flank the frame. The humans' long flowing hair and robes become entwined and merged into the plant forms themselves.

This mirror was produced at a time in Frances Macdonald's career when she was part of 'The Four'; the collective title given to her, her sister Margaret Macdonald, and the young architects – their future husbands – James Herbert McNair and Charles Rennie Mackintosh. They produced highly symbolic work that often contained ethereal, elongated human forms. It was unconventional, even daring, to use emaciated female figures as decoration, going against the accepted representations of women at the time, and 'The Four' became dubbed 'The Spook School' by their detractors. That such work was being made by women themselves strengthened the reaction against them by the male-dominated press: these depictions of 'hags' were the work of the 'New Woman', the woman who wanted to have independence, work, and eventually the vote.

This mirror is illustrated in an article published in *The Studio* in 1897 by the critic Gleeson White, who gives a vivid illustration of the way in which the work of Frances and her sister was received:

> There is legend of a critic from foreign parts who was amusing himself by deducing the personality of the Misses Macdonald from their works, and describing them, as he imagined them, 'middle-aged sisters, flat-footed, with projecting teeth and long past the hope (which in them was always forlorn) of matrimony, gaunt, unlovely females.' At this moment two laughing, comely girls, scarce out of their teens, entered and were formally presented to him as the true and only begetters of the works that had provoked him. It was a truly awful moment for the unfortunate visitor, whose evolution of the artists from his inner consciousness had for once proved so treacherous.

As the Four's intention was that every mark made, and motif drawn, had a meaning and purpose, then the imagery on this mirror frame has its own function beyond simple patterns of decoration. A friend, and fellow graphic designer and metal-worker, Talwin Morris, elaborates: 'the frame may legitimately bear upon the theme of the picture it contains and serve a more worthy end than that of a mere arbitrary line of isolation.' In Frances' mirror the two figures hold steady and point to one central honesty seed-pod, framed against the circle of the sun, positioned directly above the mirrored glass panel. The picture this frame contains is the mirror's honest reflection of the user – perhaps Frances is humorously suggesting, through the gentle play of words, that her mirror never lies.

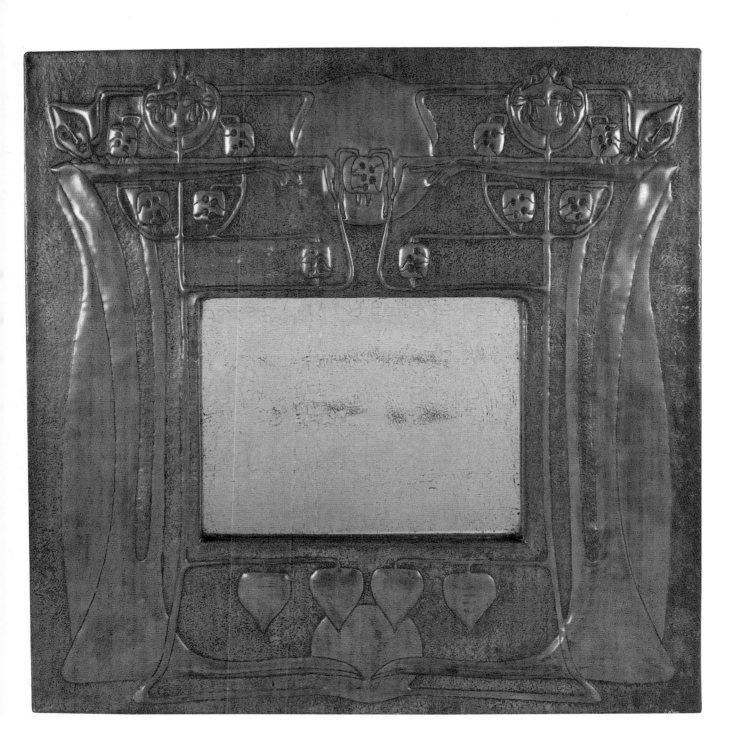

Five pieces from a bedroom suite,
*c.*1900
John Ednie (1876–1934)
Manufactured by Wylie & Lochhead
Wardrobe: oak, bronze, leather, glass;
bedside cabinet: oak, glass, bronze;
chair: oak, glass; towel rail: oak, glass;
washstand: oak, marble, metal, bronze,
leather, glass
Purchased 1988

John Ednie was one of a trio of designers who produced high-class commercial furniture and interiors for the Glasgow cabinetmakers Wylie & Lochhead. Influenced by the designs of Charles Rennie Mackintosh, he and his contemporaries used a repertoire of motifs that have now come to characterize the Glasgow Style.

Each furniture piece carries the unifying motif of the suite: the inverted heart shape, picked out in electric blue glass or ceramic on all but

the towel rail, where the glass is now presumed lost. The heart is given a different treatment on each piece of furniture. It is repeated in two groups of six in a horizontal line across the front of the wardrobe; in isolation at the top of the chair back; at the top of each end of the towel rail; and enlarged to form the 'eyes' of the metal splashback on the washstand.

The solid blocks of the wardrobe and washstand are dramatically enlivened by the carved sweeping lines that form outstretched wings across the top of each piece, culminating at the point with a second pair of wings, this time folded, on the wardrobe, and a carved stylised flower on the washstand. The carvings on the wardrobe and washstand also depict a long-stemmed sunflower, running up the centre of the wardrobe and down each of the legs of the washstand.

The bronze handles and hinges are probably from the company's stock rather than specially designed for the piece. All of the bronze fittings are backed by red painted leather, which adds intense colour spots to the furniture. The birds in flight depicted on the hinges are a recurring motif favoured by Glasgow Style designers, but originate from the work of English Arts and Crafts artists like Baillie Scott and CFA Voysey.

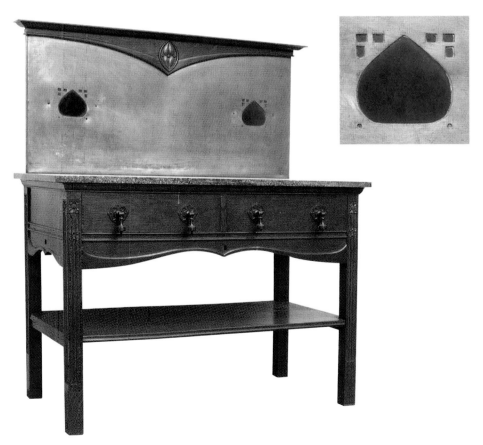

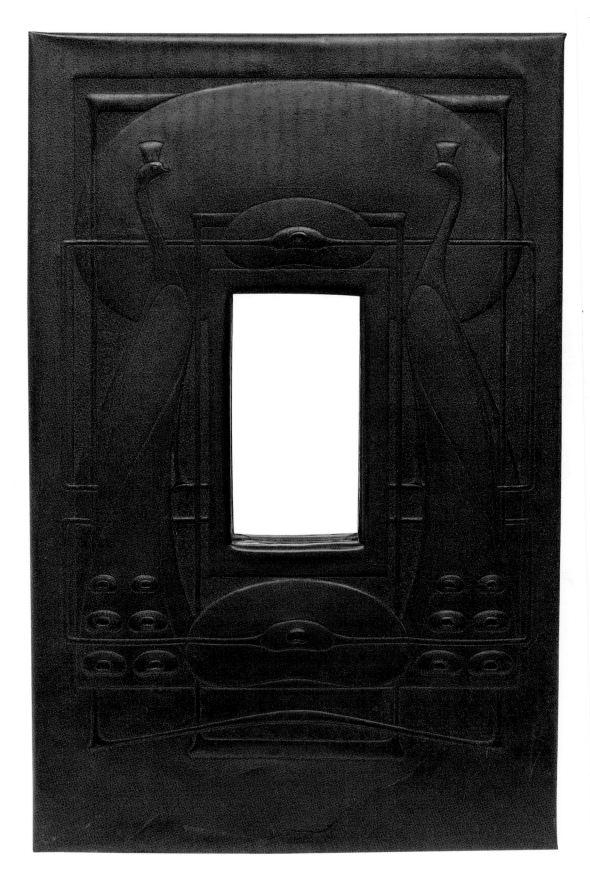

Mirror, c.1900–1
Talwin Morris (1865–1911)
Metal, with glass inserts on wood panel
56 × 35.6 cm
Presented by Mrs Alice Talwin Morris, 1946

Morris helped popularize the Glasgow Style and spread its influence through his position from 1893 as art director with the internationally respected publishing firm Blackie & Co, for whom he designed embossed spines and covers for books.

The facing peacocks design of this mirror frame appeared in an earlier, simpler, form in one such bookbinding for *The Natural History of Animals,* published *c.*1890. To incorporate the central mirror, Morris has moved the peacocks to the sides and positioned them in a criss-cross framework of vertical and horizontal lines. The large canopy of what was previously a tree has been retained, but its organic shape – a heart that has been inverted and flattened until it resembles a shape more like that of a kidney bean – is repeated symmetrically within the design; above and below the mirror, and in the peacocks' tail feathers. Morris was fond of stretching and flattening the heart shape to distorted decorative proportions, and used this

motif frequently in his designs. The peacock was another favoured motif, by both Morris and his contemporaries in Britain and abroad.

The metal surface of this frame has been treated in different ways to produce three distinct layers within the design. The recessed areas are etched with acid to give a fine matt textured background, the forms and lines of the main relief design are gently rounded, the overlapping lines adding an increased sense of depth, and the points of highest relief – including the 'eyes' of the tail feathers – are highlighted by coloured glass cabochon stones.

This mirror was displayed with work by other Glasgow designers in the Scottish section of the International Exhibition of Decorative Art, in Turin, Italy, in 1902, and was priced for sale at five guineas. Several orders for copies are known to have been placed.

Folding screen, 1901
George Logan (1866–1939)
Manufactured by Wylie & Lochhead
Walnut veneer, with silver, mother of
pearl, turquoise, red amethyst, white
stone, leather, vellum and glass
Purchased 1986

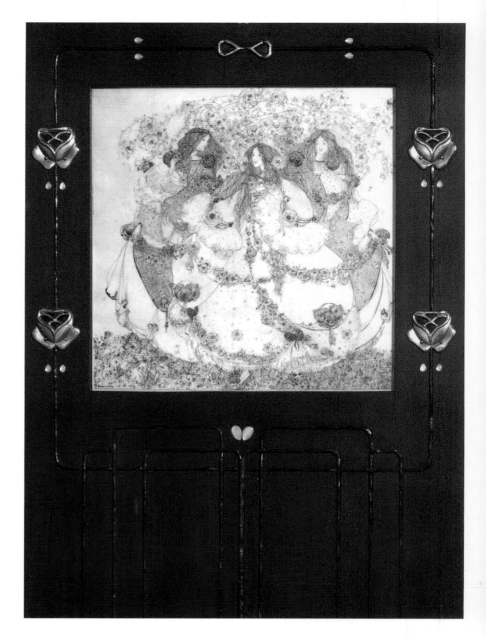

F olding screens were used for a
variety of purposes in the homes of
the middle and upper classes in the
nineteenth century. They could be
positioned to create private spaces
within larger rooms or provide a
discreet space behind which a person
could dress or undress without being
observed. However, Logan's screen
contains two eye-level oval cut outs,
each oval teasingly barred by three
silver vertical rods. As a result, his
design contradicts the traditional
function of a screen, because his
screen can be partially seen through.

The focal point of the folding screen
is an ink and watercolour drawing by
the illustrator and designer Jessie
Marion King entitled *The Princesses of
the Red Rose*. The red rose, one of the
key recurring motifs employed by
artists and designers of the Glasgow
Style, is also a traditional symbol of
passion, desire and voluptuous beauty.
Therefore perhaps with intentional
symbolism Logan has positioned the
drawing on the only panel of the
screen that provides complete
concealment of the user.

The polished walnut screen wears
its semi-precious decoration across its
surface like a woman wears jewellery
around her face and neck. The
adornment of the three princesses in
the drawing is carried through to that
of the screen itself. At head height the
silver ovals are flanked by painted red
leather and silver roses and tiny
mother of pearl drops, echoing the
white oval faces of the princesses who
all wear roses in their hair. The
princesses also wear garlands of roses

strewn with beads and jewels. The
screen has its own garlands in the
form of silver chains strewn with
pearls, turquoise and small silver
hearts that hang above the cut-out
ovals, and, more subtly, at the upper
edge of each panel, delicately carved
into the wood.

The weightlessness of the decoration
on this upper half of the screen is
soberly balanced by the simple lines of
the lower half's wooden surface which
visually weights the screen to the floor.

The finished result is an elegant and
luxurious piece of furniture, innovative
in design for its time. The screen was
exhibited in the International
Exhibition of Modern Decorative Art in
Turin, Italy, in 1902, along with a
matching desk. Logan received a silver
medal for the screen and Jessie Marion
King was separately awarded a gold
medal for a book cover at the same
exhibition. Thankfully the screen
survived a house fire which destroyed
the desk in 1937.

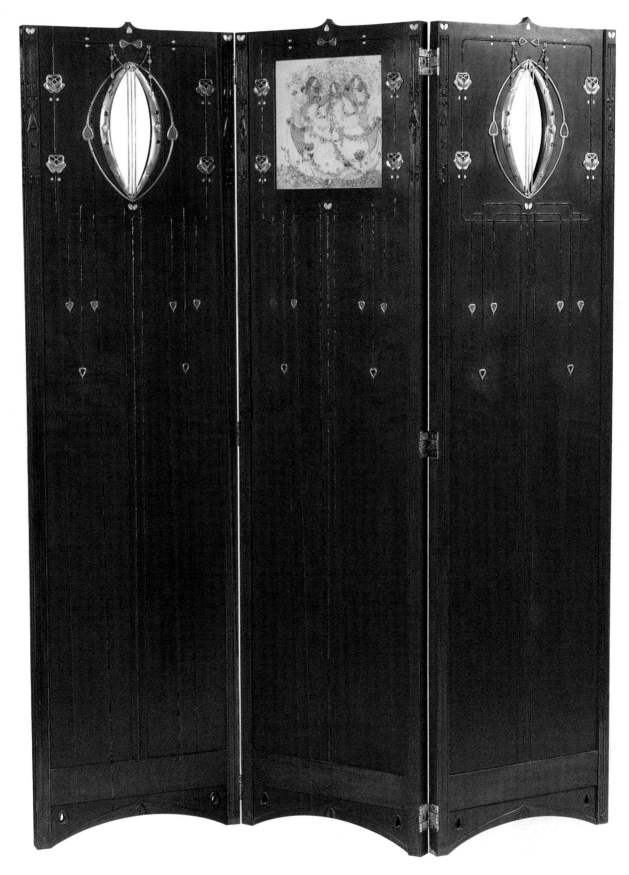

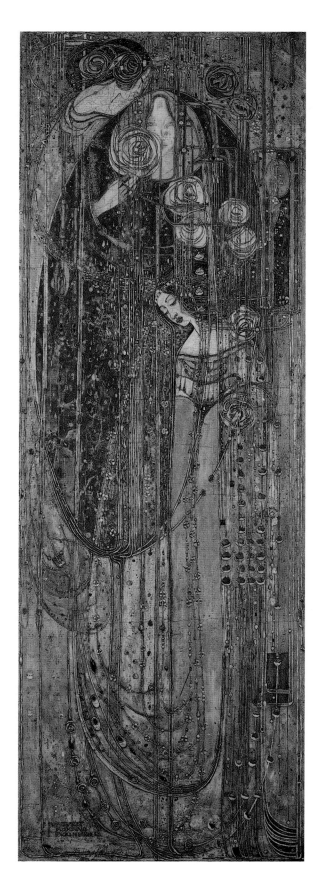

O Ye, All Ye, that Walk in Willowwood, 1903
Margaret Macdonald Mackintosh (1864–1933)
Painted gesso on hessian, set with beads
164.5 × 58.4 cm
Purchased with the generous support of the Heritage Lottery Fund,
The National Art Collections Fund, Friends of Glasgow Museums,
and the many individuals who contributed to the Public Appeal
promoted by *The Herald*, 2001

This gesso panel was designed as the figurative focal point
of the Salon de Luxe; the most luxurious of the interiors
designed by Charles Rennie Mackintosh for Miss Cranston's
Willow Tea Rooms. The tea rooms were located in Sauchiehall
Street, the fashionable shopping street in the city of Glasgow.
'Sauchiehall' in Gaelic means 'alley of willows', and this simple
translation seems to have been the starting point for
Mackintosh's and Margaret's designs for the tea rooms, as they
use the motif of the willow tree throughout the varied
decoration of the tea room complex.

The title of this panel comes from the first line of Sonnet
No. 51 from *The House of Life* by the Pre-Raphaelite poet,
Dante Gabriel Rossetti. From a series of four sonnets entitled
'Willowwood', the panel can be read as an interpretation of the
words sung by Rossetti's personification of Love. Based upon
a poem written in the first person about life, love and death,
Margaret's panel shows the women who wander forever in

mourning for their loved ones in Willowwood; their 'hollow faces burning white'. Her complex composition depicts the author's sightings of his lost love; her reflection in the rippled surface of water in a woodside well – here shown by the face set within the green oval, and her silent mournful form moving amongst the willow trees – depicted by the lower, focal figure of the panel. Margaret makes visual references to the presence of the mourning lover in the poem; the hand scooping the water from the reflected face that creates a central rose of ripples; and to the right, the tearful, almost Egyptian, eye looking on at her image in sadness.

Margaret and Rossetti both reference the willow tree's symbolic connotations in their work. In the Jewish faith the willow is a tree of lamentation; in Eastern iconography it is a symbol of the spring-time, of love, feminine grace, the sweet sorrow of parting and immortality; in Tibetan tradition it is the tree of life.

The panel demonstrates Margaret's technical ability to work in gesso – a very difficult medium to control. Gesso is a fine plaster that must be worked whilst wet and pliable, and then painted. Fluid gesso would have been piped onto the flat plaster-coated surface of the panel in fine trailing lines. The subtlety of the finished effect was achieved by painting the surface, and then by pressing glass beads into the plaster surface. The porcelain finish of the women's faces is produced by burnishing the surface of the dry gesso until smooth. The finished panel, in terms of both technique and design, is one of Margaret's most sophisticated works in gesso.

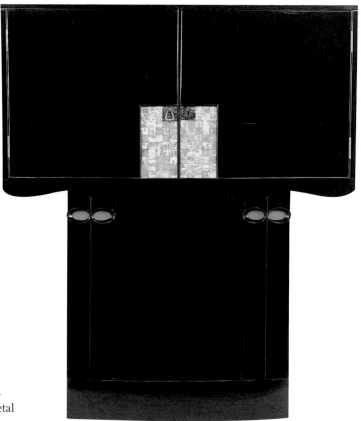

Writing desk, 1904
Charles Rennie Mackintosh
(1868–1928)
Made by Alex Martin, 1905
Ebonized mahogany, inset with
mother-of-pearl, ivory and ceramic,
decorated with leaded glass and metal
Jointly purchased with the National Trust
for Scotland, with the generous support of
the Heritage Lottery Fund and the National
Art Collections Fund and a private donor to
the National Trust for Scotland, 2002

This writing desk is considered to be one of Mackintosh's most accomplished pieces of furniture design. It was made by Alex Martin, a Glasgow cabinetmaker often employed by Mackintosh, who was paid £20 15s 6d for the work. The desk was completed in April 1905 along with an accompanying ebonized chair and pair of candlesticks, all designed for the drawing room at The Hill House in Helensburgh, Scotland. This house and its interiors, designed for the Glasgow publisher Walter Blackie of Blackie & Co, is considered to be Mackintosh's most important domestic commission.

The ebonized wood surface of the cabinet is inlaid with luxurious materials that reflect the composite shapes of the desk: squares of mother-of-pearl on the inside of the square doors and dotted lines of ivory along the inner curves at the top of the desk. These broken lines move the eye rhythmically across the front of the desk, a movement punctuated by the strong verticals of the central wooden compartment dividers. The result is a piece of furniture with proportional and musical harmony.

Inside, at the very centre of the desk, is a leaded metal and stained glass panel depicting an abstracted figure surrounded by garlands of roses. It is possible that Margaret, Mackintosh's wife, designed this panel for the desk, or at least was exceptionally influential in its design; for at this time she regularly made figurative panels that were incorporated into the completed designs of Mackintosh's interiors and furniture.

Mackintosh designed all the furniture and fittings as integral to the design scheme of the whole room – the individual sculpted forms of the furniture were linked by a proportional progression of vertical and flowing lines around the room. In the drawing room for The Hill House, where this desk now resides for part of the year, this integration is achieved through a stencilled design of silver vertical strips with stylized pink roses and green foliage along the walls.

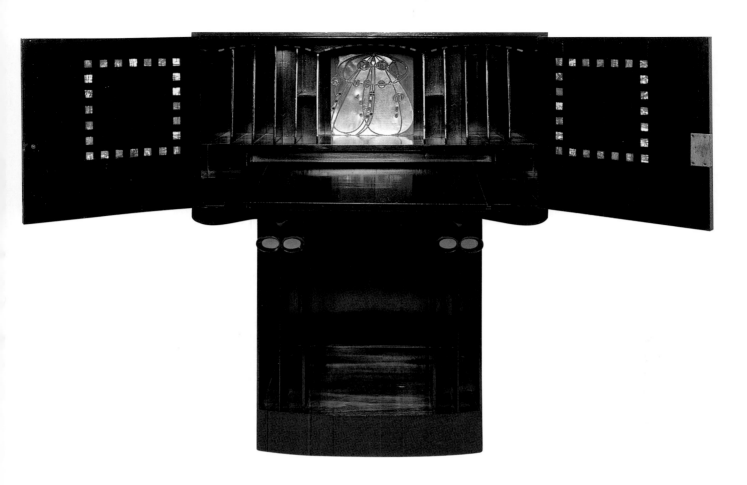

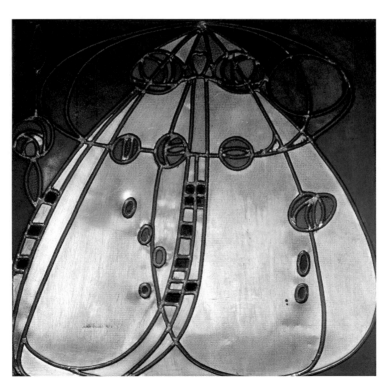

Pieces from a water set, *c.*1910
Hannah Walton (1863–1940)
Glass with hand-painted enamel
decoration
Purchased 1989

In Britain, at the turn of the twentieth century, painted enamel work was considered to be the new miniature painting; publications of the period championed its 'radiant preciousness ... the very embodiments in colour of the intensity of beauty'.

Hannah Walton was an excellent miniaturist, and her water set pieces exemplify the technique of painting enamel onto glass. The theme of water is carried through; from the actual function of the glassware to the choice of decorative subject matter – freshwater pond life and rock pools; plants, shrimps, crabs, small fish and dragonflies. The flowering plants and small fishes painted on the tumblers reappear in the largest and central piece of the set – the water jug – where they frame an Art Nouveau inspired mermaid.

The popularity of enamel decoration on metalwork and the painting of enamel onto glass grew rapidly over the late nineteenth and early twentieth centuries. New techniques in mass production – such as moulding – had led to a revival of the glass industry of Europe and America and artists and glassmakers were experimenting with the glassmaking and decorating techniques of antique models.

Students of the Glasgow School of Art, predominantly women, learnt to decorate plain, commercially made glassware and porcelain tableware. After graduating some continued to hand decorate 'blanks' for sale from their own studios. The sisters Helen and Hannah Walton, older sisters of the designer and decorator George Walton, were among the key Glasgow practitioners in this medium.

Working from the family home at 5 Belmont Terrace in Hillhead, Glasgow, where Helen had established her studio in 1881, the sisters often collaborated. Their work was noted as 'being in demand for wedding presents, always selling well'.

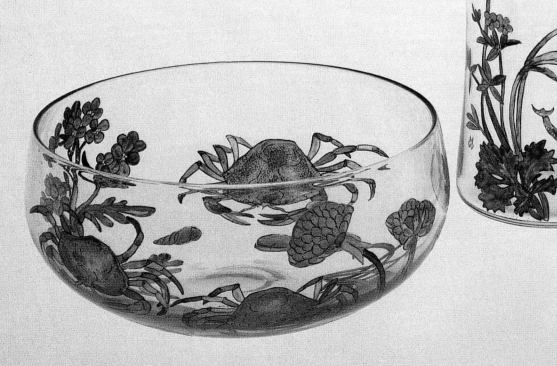

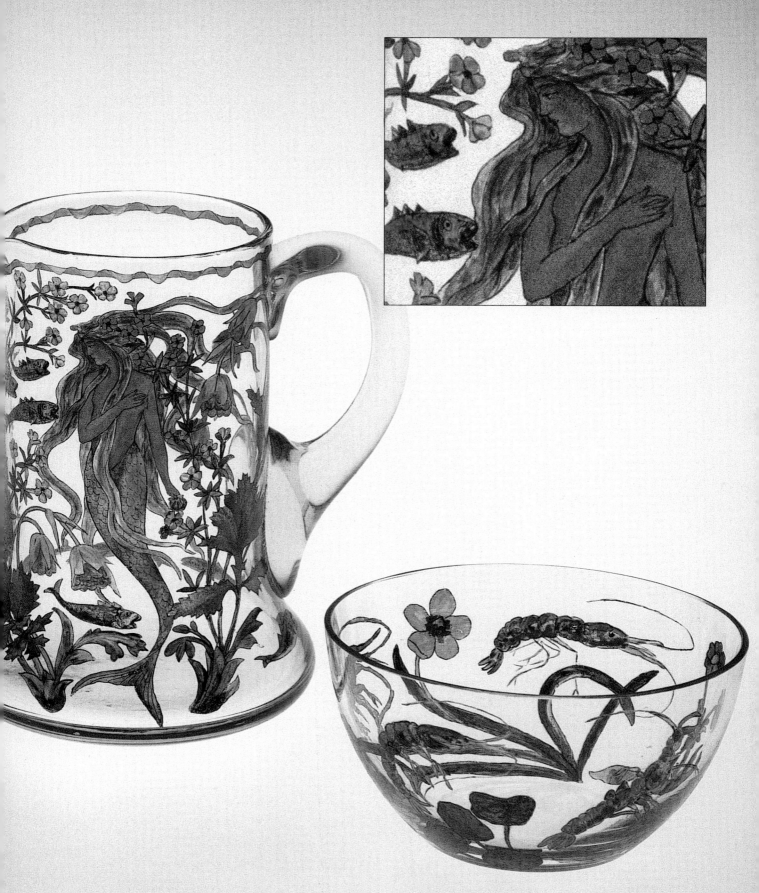

Detail from *Regina Cordium: Alice Wilding,*
by Dante Gabriel Rossetti, 1866
(see page 26)